CHARACTER DESIGN QUARTERLY

Image © Jennifer Yang

CONTENTS

04 20 24 32 44 48 58

BEHIND THE COVER ART

Artist Izzy Burton shares a tutorial for her cover artwork plus an insightful interview

THE LANGUAGE OF SHAPE

Jennifer Yang gives tips and tricks on applying shape language to characters

MEET THE ARTIST: TIM PROBERT

Tim offers insight on balance, inspiration, and the foundations of his creative journey

TUTORIAL: HOT ON THE TRAIL!

Justin Rodrigues takes us step-by-step through a criminally cool character design

FEELING EMOTIONAL

Faustine Merle provides pro tips on conveying thoughtfulness and a scheming mind

STUDIO SPOTLIGHT: RED KNUCKLES

We speak to Creative Directors Mario Ucci and Rick Thiele about their studio

PROTEST YOUR FRUSTRATION

Toshiki Nakamura shows us how he tackled the design of a climate-change protester

WELCOME TO *CHARACTER DESIGN QUARTERLY 14*

I continue to be amazed by the inspiring work of our contributors through turbulent times. This issue, the wonderful Izzy Burton has created a cover image that oozes impactful storytelling. I love that she has chosen to create a character that would have been a hero for her when she was a young girl – a zoologist living with the animals she studies, our eye cleverly drawn toward her in the mystical jungle setting. The artwork is accompanied by a making-of tutorial and an insightful interview, where Izzy talks emotion, inspiration, and working through her own self doubts.

Elsewhere in our fantasy land, Justin Rodrigues pieces together the clues to create a rounded character from a short brief, giving his aging-yet-utterly-cool 80s detective his own mystery to solve. Once you've cracked that, discover step-by-step how Toshiki Nakamura conveys a frustration we're all feeling in an emotive image of a climate-change protester.

We're always honored to interview top artists, and this time round we have Lobón Leal, Tim Probert, and the directors of Red Knuckles studio each opening up about their creative journeys, current projects, and future plans. I thoroughly escaped into the magical world of character design while putting this issue together, and I hope you can do the same. Enjoy!

SAMANTHA RIGBY
EDITOR

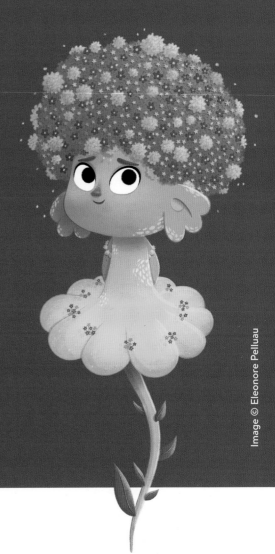

Image © Eleonore Pelluau

70
CHARACTERIZE THIS

Eléonore Pelluau takes the words "shy blossom" and creates a stunning character

72
MEET THE ARTIST: LOBÓN LEAL

This incredible artist discusses teaching at ESDIP and shares some personal work

80
GALLERY

Lose yourself in the art of Tom Goyon, Marie Vanderbemden, and Stacey Thomas

88
DESIGNING FROM A NARRATIVE

Meybis Ruiz provides an indepth tutorial on designing from a narrative text

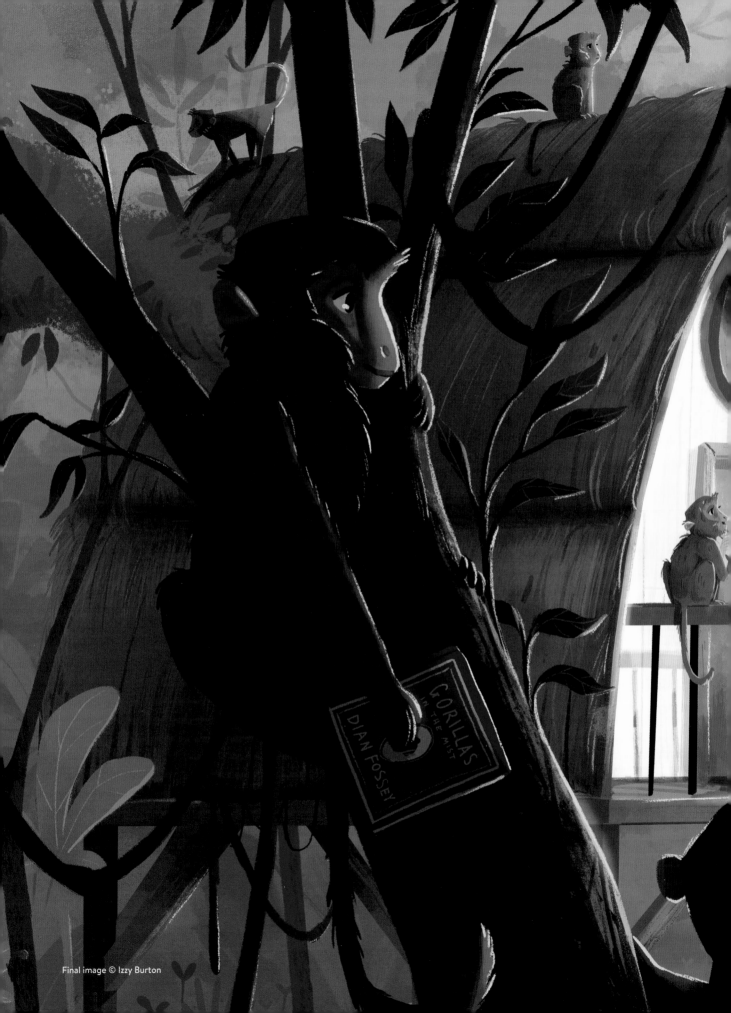

Final image © Izzy Burton

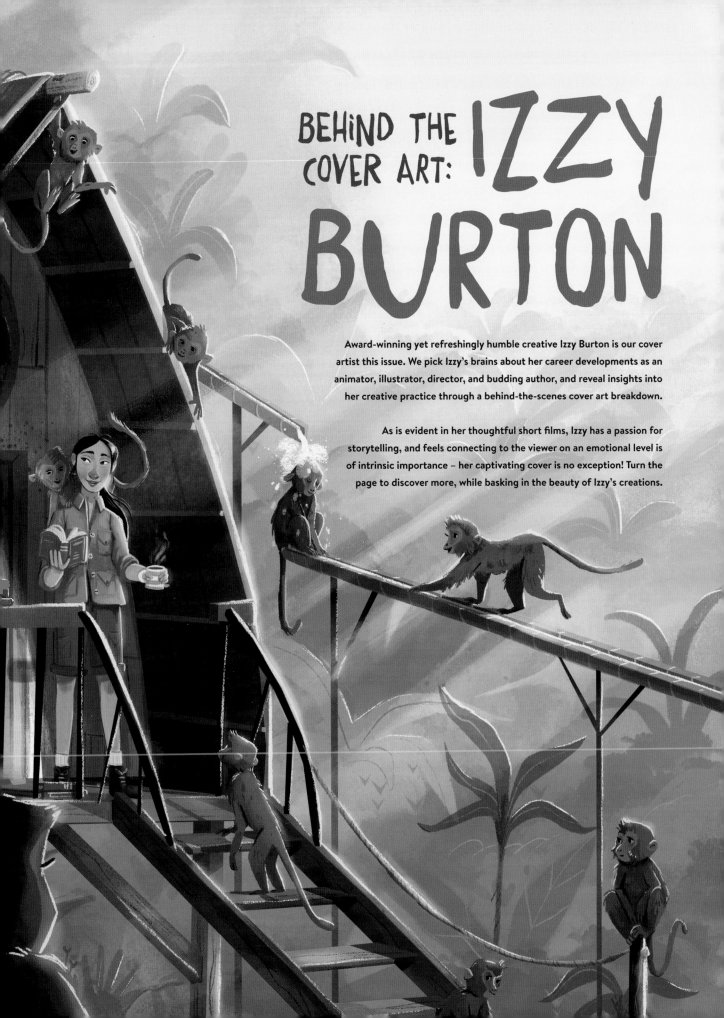

BEHIND THE COVER ART: IZZY BURTON

Award-winning yet refreshingly humble creative Izzy Burton is our cover artist this issue. We pick Izzy's brains about her career developments as an animator, illustrator, director, and budding author, and reveal insights into her creative practice through a behind-the-scenes cover art breakdown.

As is evident in her thoughtful short films, Izzy has a passion for storytelling, and feels connecting to the viewer on an emotional level is of intrinsic importance – her captivating cover is no exception! Turn the page to discover more, while basking in the beauty of Izzy's creations.

MEET IZZY

Hey Izzy, thank you for creating such a beautiful design for this issue's cover! Could you tell us and our lovely readers all about yourself and your creative journey?

Thank you so much for having me! It's an honor to design a cover for *CDQ*. If I rewind right back to the beginning, when I was just a kid, I spent all my time writing stories and illustrating them. I was lucky enough to be surrounded by nature, and have a mother who taught me all about it.

I ended up studying Animation at the University of Bournemouth, UK, in a bid to combine my love for Math and Art. University was a reality check for me; I almost quit in my first year because I thought I wasn't good enough. But I persevered and focused on making lots of short films. At the end of university, one of my short films was awarded "Best Final Year Film" by Blue Zoo Animation, which was such a shock as I thought I was rubbish! They then offered me a job as a concept artist, which was another big shock as I hadn't been applying for concept-art jobs. Despite my own self-doubts, I ended up working there for four years, and worked my way up from Art Director to Director following the success of my short film, *Via*.

In June 2019, I made the decision to go freelance as I wanted more of a challenge and to change the type of work I was creating. Since then, I have found representation as a Director through Passion Pictures as part of their emerging talent roster, "The Greenhouse," as well as through Paris-based studio, Troublemakers, and the Bright Agency for illustrative work. I have a lot of fun trying to juggle working in animation and illustration – it's pure madness trying to do it all, but I love it!

Recently, I released a new short film entitled *Stella* with Passion Pictures in collaboration with a charity called Re-Engage, who help to combat loneliness in the elderly community. I'm also working on a children's fiction chapter-book series, which my agents are sending out to publishers – hopefully I can add "author" to my job title soon!

This spread: Images © Izzy Burton

Opposite page (top):
Somewhere near Norway

Opposite page
(bottom): *Tranquil*

This page: *Catrina*

What drew you to designing characters in particular? And of the characters you have created so far, do you have a favorite?

I was initially very scared of character design – maybe I shouldn't be revealing that in a magazine about character design?! I love it, and I am always in awe of the work my industry friends create. I think I avoided it because I thought I wasn't good enough (re-occurring theme here!). I learned though, as a director and a storyteller, that character is so important, and not something I could continue to avoid. I knew I needed to improve my skills in regards to character design to pitch my stories and make them more believable.

When I pitch as a director, be it for commercials or short films, I create all the artwork, which usually includes characters. I realize now that I'm still learning, as sometimes I still get frustrated that my designs are too rigid or uninteresting. But I try to remind myself that we are all on our own artistic journey and improving every day. I try to be proud of what I can do, rather than pick apart what I cannot. Since adopting this mindset, I have much more fun with character design, as I have lifted some of the unnecessary pressure I was putting upon myself. Every design does not need to be perfect, it's all about learning and experimenting.

Undertaking children's book illustration has me drawing characters more frequently. They need to carry a similarity from page to page, which has taught me a lot. Being asked to do the cover for this issue made me experience some imposter's syndrome, so I really hope the readers like what I've created.

As for my favorite characters, I think it has to be Stella – the old lady from the short film that is named after her – and the blackbird that stars alongside her. I based Stella's little grandma qualities on my own short-statured grandma, which was really fun to do!

When you start personal projects or client work with open briefs, where do you look for inspiration? And how do you transform that inspiration into unique and original designs? What do you enjoy most about working with the tools/media you use?

I start projects with lots of research – I often end up in the endless pit of Pinterest, or looking at old photos on Flickr. Sometimes I delve into history, as there is so much inspiration to find in events or people from the past. I like to create mood boards with the references I gather, sometimes including character designs I like, but I try to use these loosely as a reference as I don't want to copy other designs or deviate away from my own style.

I'm adamant that I want my characters to feel like they're mine, so I like to draw a few quick sketches without any reference to other designs or photographed poses. This way, if I

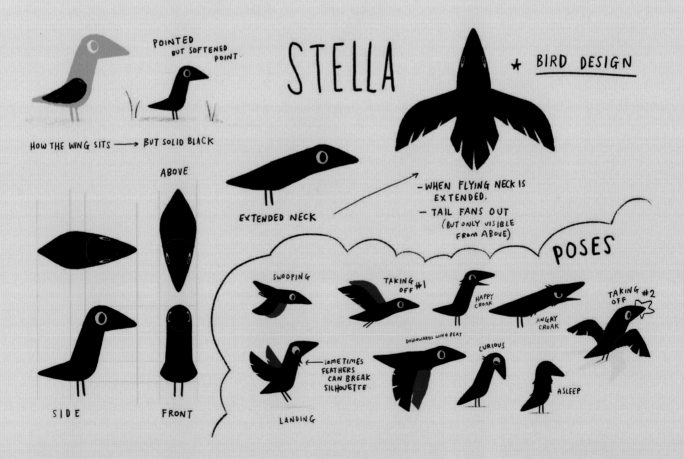

POINTED BUT SOFTENED POINT

HOW THE WING SITS → BUT SOLID BLACK

STELLA

★ BIRD DESIGN

ABOVE

EXTENDED NECK

– WHEN FLYING NECK IS EXTENDED.
– TAIL FANS OUT (BUT ONLY VISIBLE FROM ABOVE)

POSES

SIDE

FRONT

SWOOPING

TAKING OFF #1

HAPPY CROAK

ANGRY CROAK

TAKING OFF #2

DOWNWARDS WING BEAT

CURIOUS

SOMETIMES FEATHERS CAN BREAK SILHOUETTE

LANDING

ASLEEP

Happy Worried Surprised Laughter

Sad asleep 01 asleep 02 just woke up

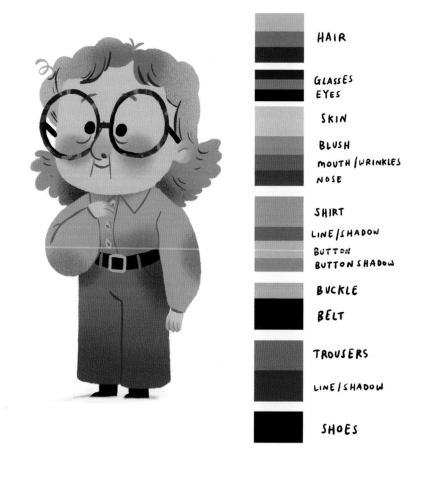

HAIR

GLASSES
EYES

SKIN

BLUSH
MOUTH/WRINKLES
NOSE

SHIRT
LINE/SHADOW
BUTTON
BUTTON SHADOW

BUCKLE

BELT

TROUSERS

LINE/SHADOW

SHOES

get stuck with the design later on, I can use references, but the design remains rooted in my style without being heavily influenced.

For many of my short films and stories, I try to find inspiration in the real world. As mentioned previously, in the short film *Stella*, I based the main character on my own grandma, transferring her looks and personality into the design. It's easier to make characters and stories more authentic when you gather inspiration from reality. I believe it's a good way to achieve a sense of originality, too, as humans are all unique. Because no person is alike, it's the best way to have a unique character while avoiding stereotypes on what the character should or would be like.

When creating character designs, I like to work digitally because it allows me to cut and paste parts of my design, edit them, pull them about, and finesse them. This takes away a lot of my fear about creating characters, as they don't have to be perfect from the moment I start.

When creating a character or character-driven scene, what do you hope to convey to the viewer?

Emotion – it's always emotion for me. For my characters, my concept pieces, illustrations, short films, and my writing. I want the viewer to understand the character and relate to them. If a viewer can invest in a character within a story, then they will be drawn into the world and care about what happens to them.

In my short film *Via*, the characters are tiny, partly because I was worried I wasn't skilled enough to create characters that viewers could relate to in close-ups. By keeping their design simple and graphic, and making them smaller, they became almost anonymous (they didn't even have full faces, just noses and eyebrows). The feedback I received was really interesting – lots of people told me they felt the story was about their own life. Because the characters were simple and faceless, viewers could project themselves onto them. This helped people invest in the story – as it became about them – and feel the emotion I wanted them to feel.

This spread: Stills from
the short film *Via*.
© Blue Zoo Animation

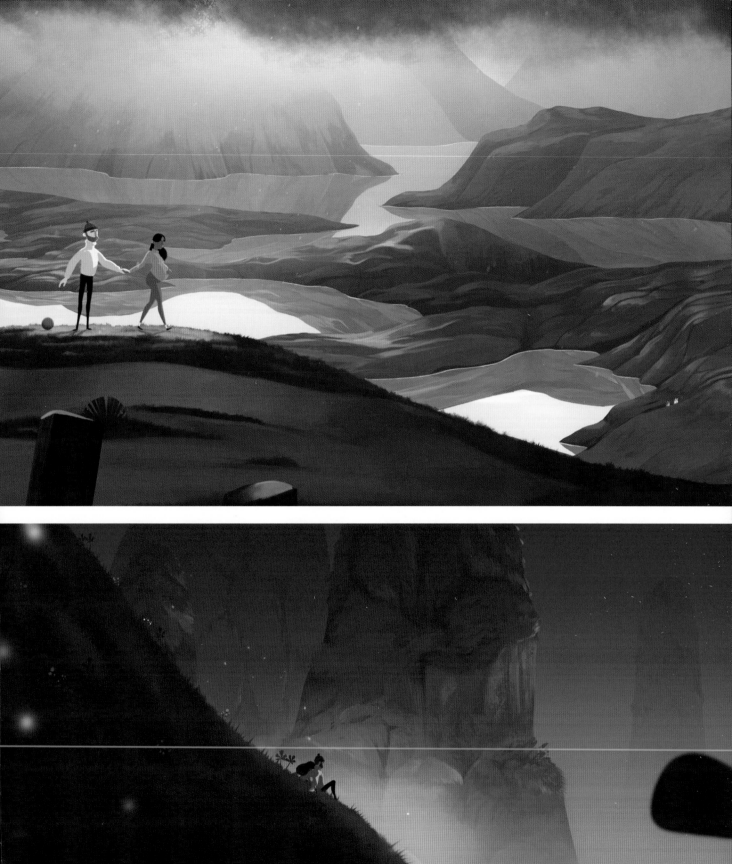

CRAFTING THE COVER: THE PRIMATOLOGIST

This magazine is always full of my art heroes, so for the cover I wanted to create a character who would have been my hero as a young girl. When I was little I wanted to be a zoologist and my hero was Charlotte Uhlenbroek, and later I learned more about other women in the field, such as Jane Goodall and Dian Fossey. These women were really important to me, and so to begin this design I looked into current-day conservationists. I was interested in exploring WOC (women of color) for this design too, researching real-life incredible women outside of what I knew as a child.

RESEARCH AND INITIAL DESIGNS

I had a strong image in my head of what I wanted to create, so I immediately started gathering references of rainforests and researching WOC in conservationist roles. Some of the women I found include Crystal Egli, C. Parker Mcmullen Bushman, and Dr. Andie Ang. Out of

them all, Dr. Andie Ang caught my eye because she is a primatologist, just as I had envisioned for my character. As president of Jade Goodall's Institute in Singapore she also won the "Great Women of Our Time Award for Science and Technology" in October 2019. I created designs based on all the women I researched, but the Dr. Andie Ang inspired character stuck with me.

DEVELOPING THE CHARACTER

My initial idea was to create an older or perhaps middle-aged character for this brief. However, inspired by Dr. Andie Ang, I decided to make her a little younger. I took my initial sketch and played with it until I was happy. I wanted to pose her handing a banana to a monkey, but in the end, I felt this was too forced and a little obvious. Instead I opted for a more relaxed pose: showing her trying to drink her morning coffee and do some research while the monkeys steal her books.

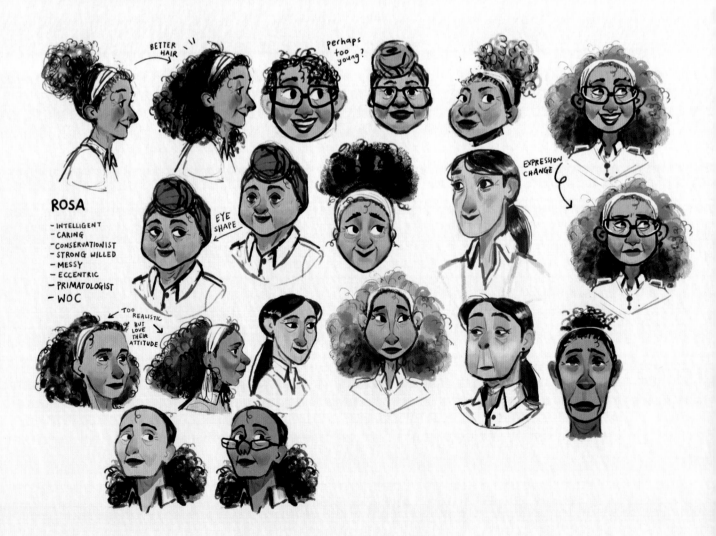

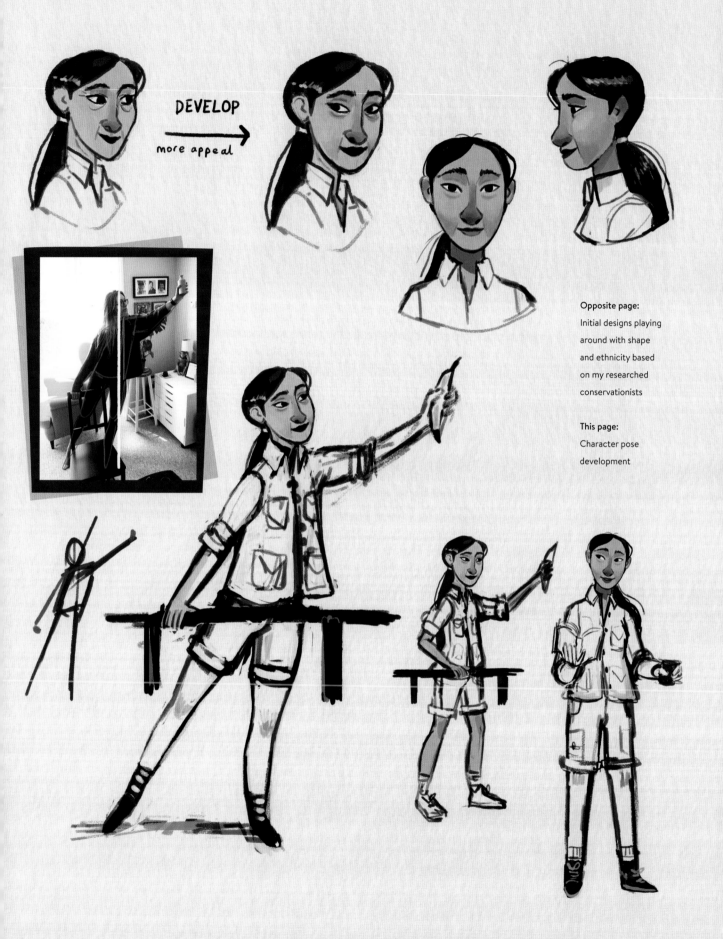

DEVELOP
more appeal

Opposite page:
Initial designs playing around with shape and ethnicity based on my researched conservationists

This page:
Character pose development

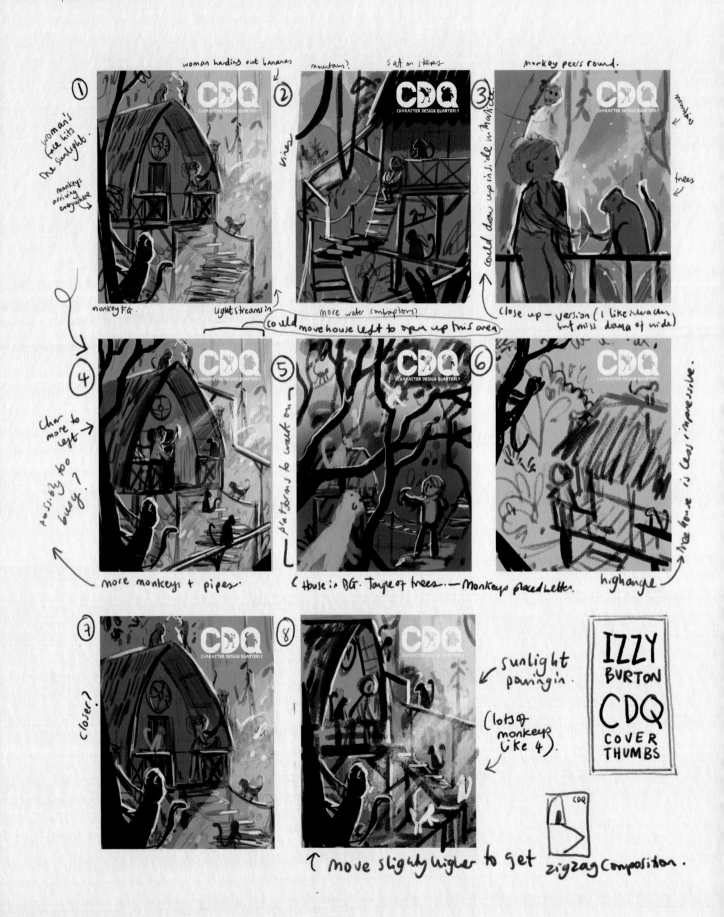

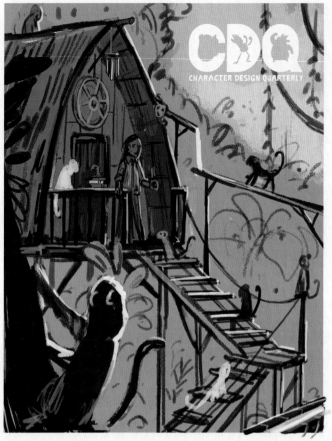

THUMBNAILS

As I had such a clear image in my head, when I begin thumbnailing it was the first image I drew. I played around with different compositions – placement of the treehouse, perspective, and design elements. After some exploration, I returned to my initial thumbnail and made it stronger by using the stairs to add a more deliberate zigzag through the composition, and by adding a large monkey in the foreground to give a sense of depth.

MONKEYS

The next daunting task was designing the troop of monkeys. I wanted them to be as simple as possible, while still existing in the same world as the primatologist character. I drew some loose sketches, trying to capture the slightly hunched-back shape that monkeys have, and the almost geometric shape of their legs when they sit down. I wanted them to be cheeky, but also cute, so I explored further sketches before landing on the final designs.

Opposite page: Thumbnails exploring different compositions

This page (above): Final layout

This page (below): Sketching my cheeky-yet-cute monkeys

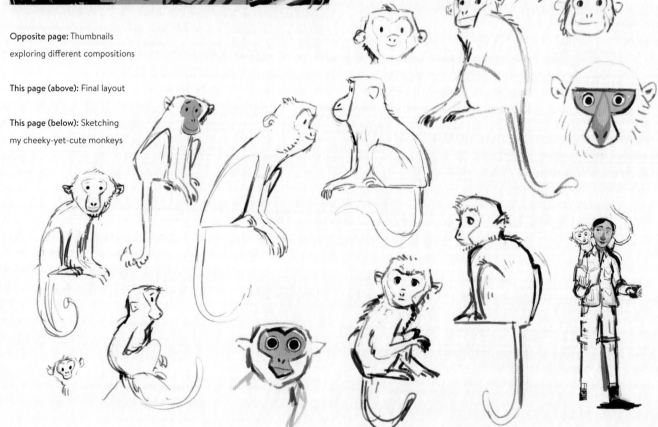

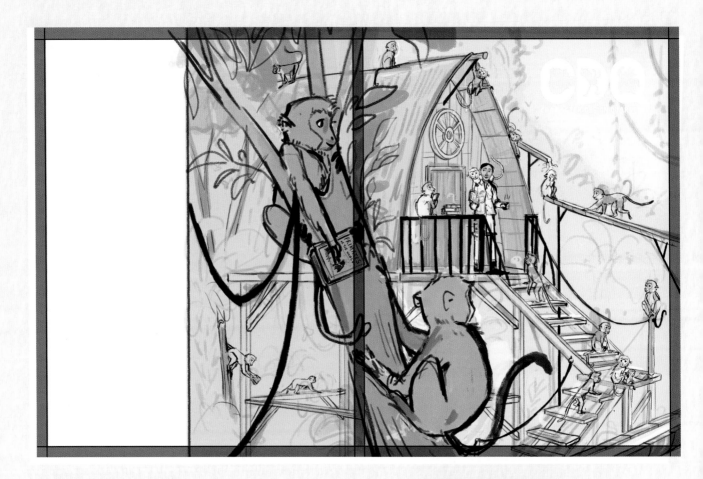

FINAL SKETCH

Next, I assembled and developed the final sketch. The aim of this stage is to make sure that my characters are sketched out with enough information for me to color them effectively. I also neatened up the building sketch, as this was another area where painting had to be precise. I left the rainforest loose because I wanted to build that up as I painted in the color, and not be penned in by my sketch boundaries.

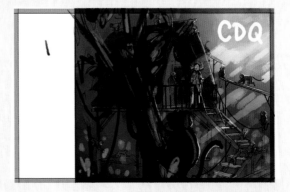

COLOR ROUGHS

Color roughs are a really important step. They create a guide to laying down the final color, and are a good chance to experiment with the feeling you want to portray without going too far into detail. In my head this scene was a really damp gray-green rainforest, but I used warmer lighting to help tell my story of the character enjoying her morning coffee. When I color my final art I often zoom out so my canvas is tiny on screen, and compare this with my color rough to check I'm getting the atmosphere I set out to achieve.

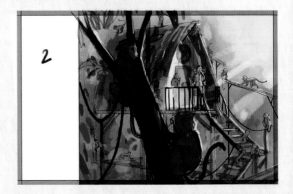

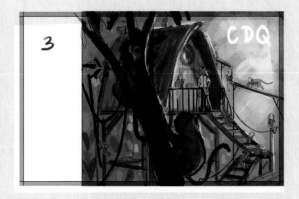

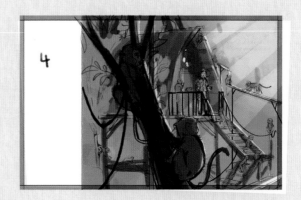

MORE NATURAL PALETTE → FOCUS ON GREEN

FINAL EDITS

Top left:
The final sketch

All other images:
Experimenting
with color and
atmosphere

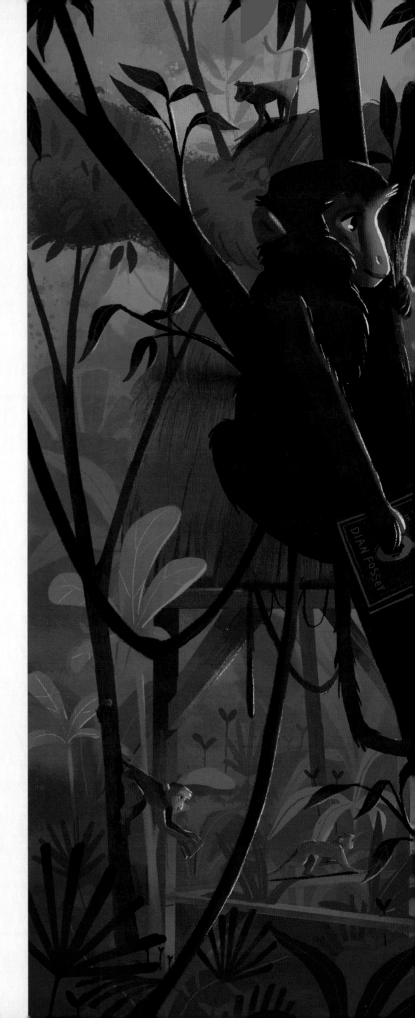

"YOU WANT YOUR VIEWER TO BE DRAWN TO THE SUBJECT OF YOUR ARTWORK AND NOT BE DISTRACTED BY EVERYTHING ELSE"

FINAL ART

With all the previous steps thoroughly prepared and executed, I applied the final color layer, feeling confident in rendering my final image because I had spent time planning my approach.

DON'T OVER-DETAIL

With this piece it was really hard not to go overboard with detail – having seventeen monkeys to draw and give personalities to was a bit chaotic! To ensure the final image stayed readable and clear, I decided to keep the background of the rainforest quite subtle. This meant pushing the leaves back into tones of the same blue, green, and yellow throughout the image, only adding highlights to the leaves in the top-right of the scene.

Initially I wanted a contrasted, shadowy forest, but that would have been too much. You want your viewer to be drawn to the subject of your artwork and not be distracted by everything else. Here I have tried to draw the viewer's eye by making the stairs zigzag toward my hero character, and by adding a pop of red with the book she is reading. I also added an edge light to help her stand out from the shadowy part of the house behind her. By focusing the detail in her immediate area, or at least leading to the area she is in, I can draw the viewer's eye toward her.

This spread: Final cover
art design © Izzy Burton

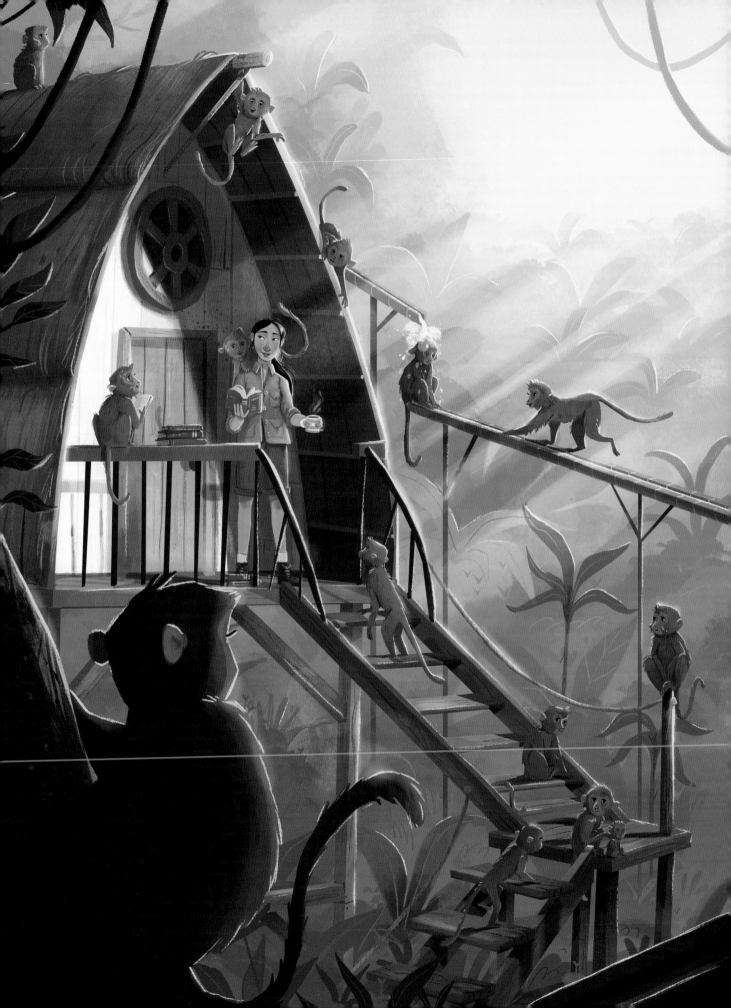

THE LANGUAGE OF SHAPE

JENNIFER YANG

In this tutorial, I reveal some of the tips and tricks I keep in mind when applying shape language to my characters. Normally I work intuitively and do not go through a step-by-step process, but it is interesting to take a step back and organize my thoughts. Some of the tips include working with shape, color, and scale, and how to bring it all together in a single character. I use Procreate initially, to draw the illustrations, and then Photoshop to compile and edit them.

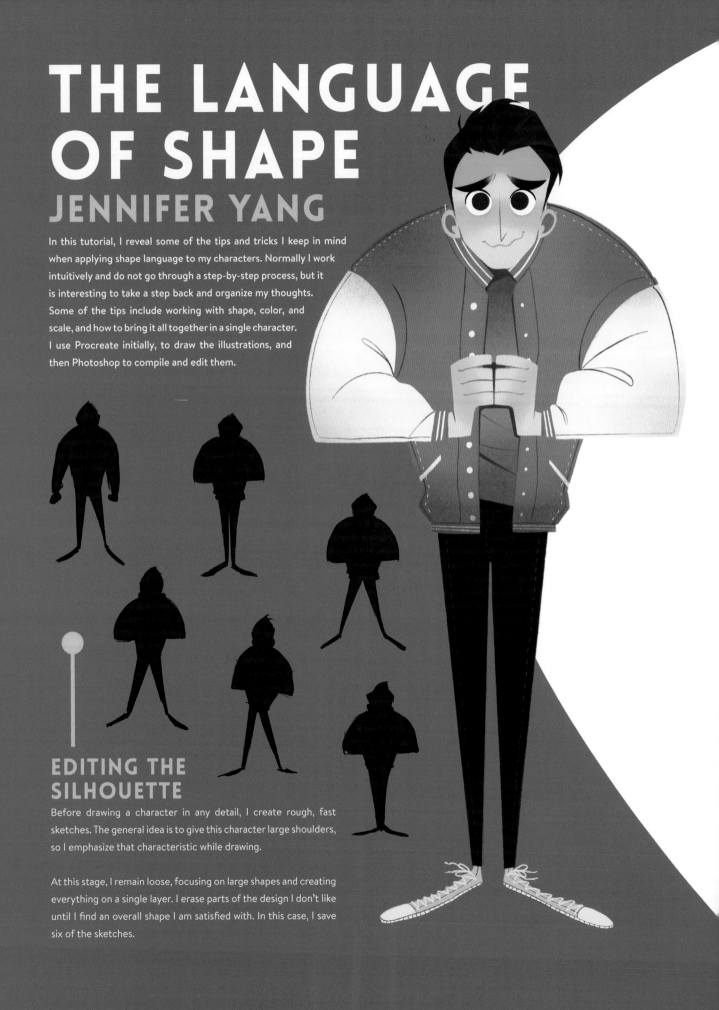

EDITING THE SILHOUETTE

Before drawing a character in any detail, I create rough, fast sketches. The general idea is to give this character large shoulders, so I emphasize that characteristic while drawing.

At this stage, I remain loose, focusing on large shapes and creating everything on a single layer. I erase parts of the design I don't like until I find an overall shape I am satisfied with. In this case, I save six of the sketches.

CURVED VERSUS STRAIGHT LINES

I like to mix curved and straight lines to create dynamic, appealing contrast and balance for my character. Depending on the personality I want to convey, I push and pull the lines to make them smooth or angular. Generally, predominantly rounded characters are perceived as "nice" while characters with a lot of spiky features are seen as "mean." Experiment with different shapes and personalities to see how this works.

ACCESSORIES TELL A STORY

I have great fun choosing accessories. Just one or two well-placed items drastically change how the viewer will perceive a character. You can tell different stories through the choice of accessories. For example, the combination of baseball cap and rucksack offer a sporty narrative, while the glasses and classic school satchel hint at a "nerdy" character and story.

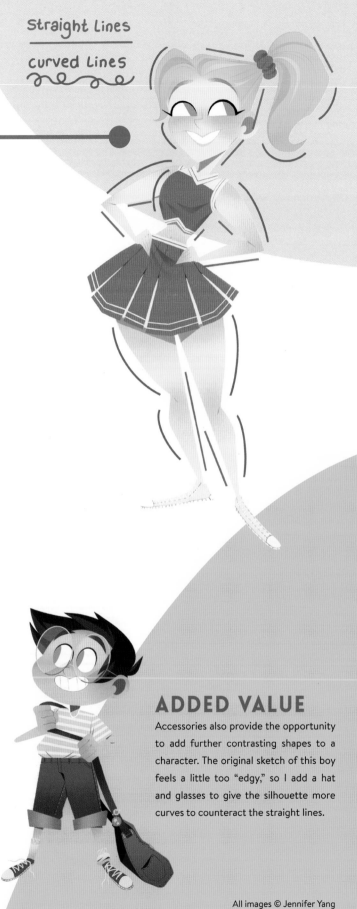

Straight Lines

Curved Lines

ADDED VALUE

Accessories also provide the opportunity to add further contrasting shapes to a character. The original sketch of this boy feels a little too "edgy," so I add a hat and glasses to give the silhouette more curves to counteract the straight lines.

WAYS TO
USE COLOR

One of my favorite features to draw is hair, which I often exaggerate. However, this can lead to the hair overpowering the silhouette. To counteract this, add balance with your use of color in the clothes and body. This character is angular in design and the hair takes up a significant portion of her silhouette. Because she has a moody vibe, I color her clothes using muted tones that still stand out from the dark hair; intense brights would be out of character and upset the balance.

PLAYING
WITH SCALE

I place the characters side-by-side and scale them to the size I envision each to be. On a separate layer, I duplicate the line-up and color each figure in black to create silhouettes. Without the color and detail, it is easier for me to see that the shape and size of the characters work, both independently and as a group. Experiment with size and scale in this way to differentiate characters and ensure a dynamic, interesting group.

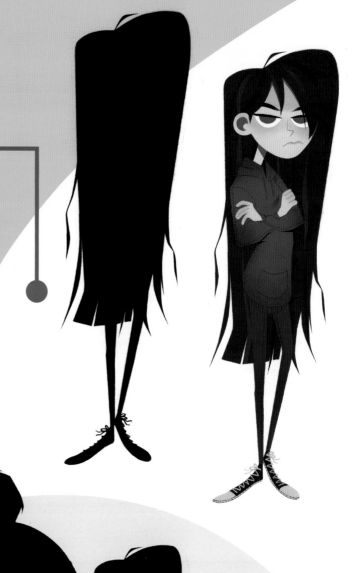

SIZE
SURPRISE

You can also play with the size and scale of accessories and clothing to create different effects. For example, the contrast of an unexpectedly dainty accessory on a big, bulky character can add narrative, interest, and often humor.

"PERSONALITY
IS A SIGNIFICANT
COMPONENT OF
CHARACTER DESIGN"

ALL TOGETHER NOW

Now that you have a set of complementary characters, it's time for them to interact as a group! As always, personality is a significant component of character design. Drawing the characters reacting to a scenario is a great device that allows you to play with their shape, pose, and expression. Vary poses and put your characters in scenarios that build a back-story for them, making them relatable and intriguing to your audience.

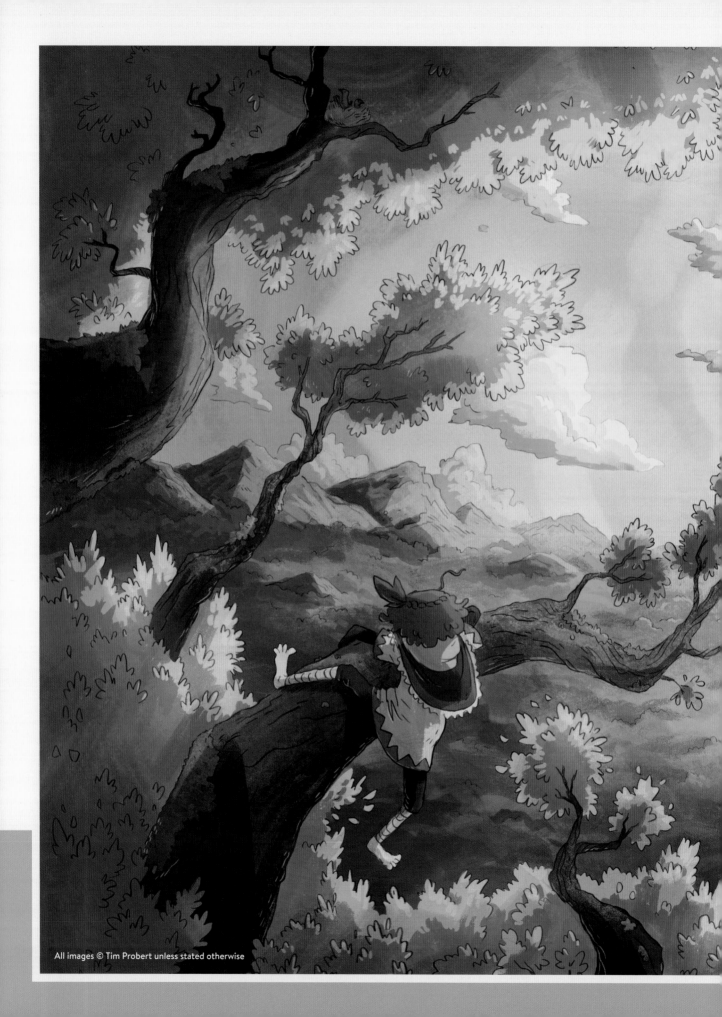

MEET THE ARTIST:
TIM PROBERT

Art Director Tim Probert takes the time out of his busy schedule to tell us about his hectic life. Juggling personal and commercial projects, he offers insight on balance, inspiration, and the foundations of his creative journey.

Hi Tim, thanks for making time to chat to us, we really appreciate it! For the readers who don't know anything about your work, could you tell us about what you do, and the creative journey that got you there?

Of course! Thanks for having me. My creative journey has been a bit of a winding road. When I finished high school, I knew I wanted to pursue art, but wasn't sure which area to go into. I went to Boston University to study painting – it was a classical program and I learned many traditional techniques. While there I decided to move into animation, specifically design and story animation, and in my spare time taught myself how to use software such as Adobe Photoshop and Toon Boom.

So, would you say you are largely self-taught, and would you recommend this path to other budding character designers? It would be interesting to hear your thoughts on formal education versus online training and self-teaching?

For me, it's more of a combination. In school, I learned about drawing fundamentals such as anatomy, composition, color theory, and light, all of which are extremely important for design and animation. I took these skills and applied them to my own designs. It's hard to say if this route would work for everyone, as I think it depends on the individual. There are a lot of great online courses as well as traditional schools to choose from. In the end, I think the skills you learn and the quality of your portfolio is what's important, as opposed to how you got there.

After I left school, I started an internship doing cleanup animation, then bounced around for a while. I started heading down two paths – doing freelance illustration for books and magazines, as well as freelance animation. I

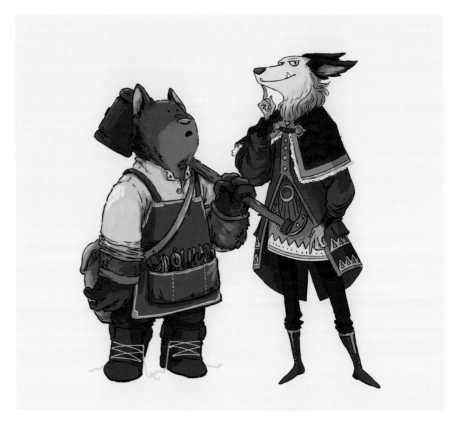

worked on a middle-grade book for MacMillan and they asked me to do a series. At this time, I also started designing for Nickelodeon and ended up freelancing at the animation studio Nathan Love in New York.

I eventually went full-time at Nathan Love, creating storyboards and designing all sorts. I directed a bit, but eventually moved on to being Art Director. I kept freelancing too, wrapping up the series for MacMillan and developing a short for Nickelodeon. The short was *Bea & Cad*, which Nathan Love produced with animation from Studio La Cachette in Paris. I'm super proud of that short, but it ended up not moving forward. The Art Director I worked with at MacMillan became Editorial Director for a new graphic-novel imprint at Harper Collins. I pitched him *Bea & Cad* as a graphic novel, and now I'm doing two books for them. All while still doing my full-time job, which brings us up to present day!

Your illustrations often feature soft color, organic forms, and a hint of magic. Is this representative of the style of all your art, and what are your thoughts on "style" itself?

I love magic and there are certain colors that I gravitate toward. But versatility is also important, and being adaptable is a necessary skill, especially in commercial work. Style is a tricky thing. You definitely want your work to stand out, but you don't want to get pigeon-holed into one specific style. I think having a point of view that you can bring to your work is more important than a style. Sometimes, the style you like working in might not be right for a particular project, but you can still bring your individual approach to make it special and different from what anyone else might do. That will help your work stand out and feel unique.

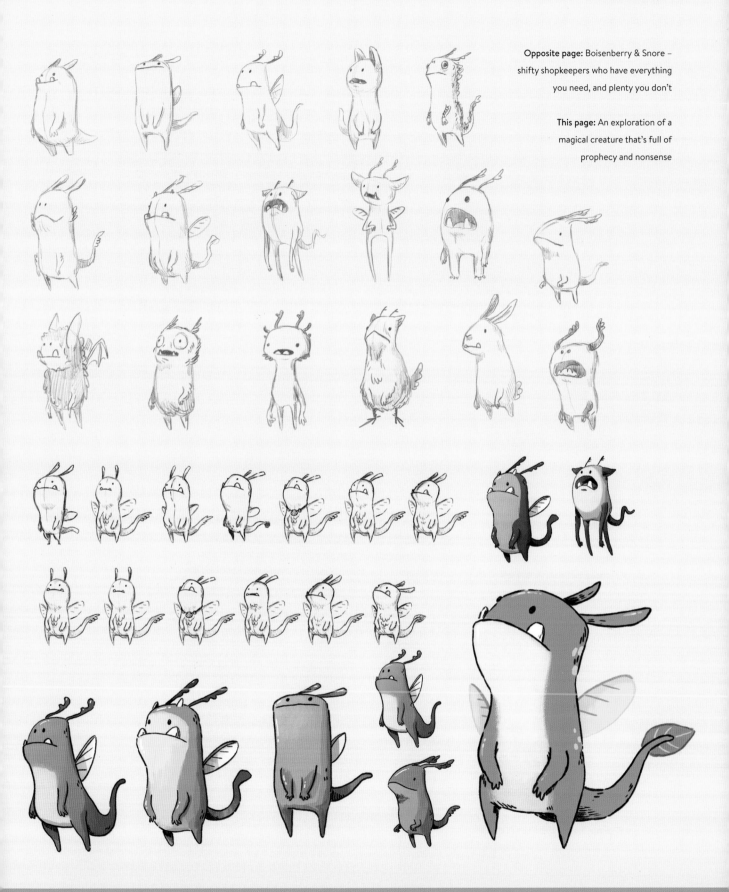

Opposite page: Boisenberry & Snore – shifty shopkeepers who have everything you need, and plenty you don't

This page: An exploration of a magical creature that's full of prophecy and nonsense

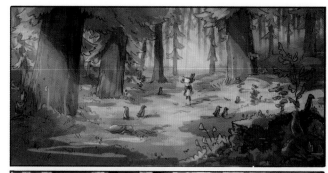

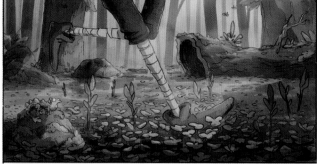

Would you say this "point of view" is developed from personal experiences rather than art training?

It can be! Art training will influence your art style, and might also influence your point of view. But your life experiences will also influence your point of view. It's all these little things that make you an individual and help you bring something to a project that no one else can.

Tell us more about *Bea & Cad*, and where your concept for the story originated.

The ideas for *Bea & Cad* have been kicking around for a while – it's been in development for about six years at this point. It's gone through lots of changes but the core has stayed the same. I wanted to tell a story about relatable, flawed characters that are in over their heads in a fantastical world. They are heroes with anxieties and insecurities that do the right thing anyway. I also wanted to tell a big fantasy epic where the goal isn't to save the world, but to try and make it better. A lot of

the characteristics come from my personal experiences. Anxiety is something I deal with daily, and I've had to learn to handle it. But it's helped me grow. I hoped this would come across in the story. I filtered in a lot of my influences and passions to try to make something personal and hopefully relatable to a lot of people. The story has gone through a lot of changes and different formats over the years – it was a short for Nickelodeon, a mini-series, a full series, a movie; we even changed the name to *Lightfall*. In the end, a graphic novel felt the most natural. It gives the story all the space it needs to breathe and grow naturally.

Opposite page: The cover for my graphic novel, *Lightfall*

This page: Two pages from *Lightfall* showing the character Bea exploring the woods near her home

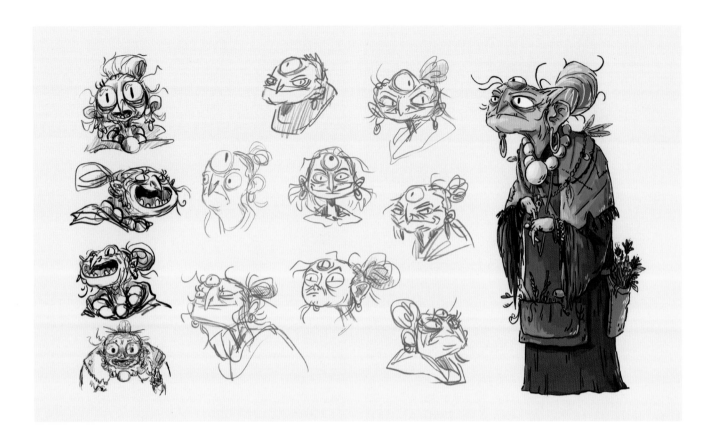

Through your work, do you hope to help destigmatize mental health issues?

Absolutely, I hope to highlight that struggling with anxiety and depression are not character flaws and that it is okay to have those feelings. Especially for younger readers, I wanted to show them a character who deals with these difficulties, who tries to understand them and work through them to accomplish great things. Throughout the story, Bea might get anxious and hesitate, but she fights through it and keeps going. If that inspires readers, I'd be very happy.

What do you do when you're looking for inspiration, and can you suggest ways to get inspired for other artists feeling stuck in a creative rut?

One thing I like to do is go for a walk. It seems so simple, but I find it hard to focus when I'm struggling for ideas and just want to push through. Going out can help this. You can push through a deadline, but it is harder to push through to find inspiration. When I'm in a rut, breaking up my routine usually helps. I like to go out to the woods, camp, travel, explore, or read. Experiencing something that is different to what you are working on can help – you never know where inspiration might come from. Putting the work away for a day can also do wonders – there's nothing like a night off to clear out a dusty brain.

How do you balance your schedule as Art Director for Nathan Love with working on your personal projects?

It is sometimes a game of spinning plates, and everyone has their own methods and preferences. Personally, I like to do my personal projects in the early morning, putting in some time before heading to work. When the book came along, the studio offered me the opportunity to go down to working four days a week. I'm really lucky to have that opportunity, which I know is a unique situation. Inevitably, it also comes down to scheduling and time management. I try to plan out my weeks and stick to the schedule as best I can (I usually can't, but I try!). It's also important to take time for myself to keep the mind fresh, and so I don't go crazy.

Do you have any advice that could help budding character designers break into the industry?

Practice, practice, practice. I know it's cliché, but it's true. Build up your portfolio, especially with the kind of work you would like to do professionally. Set yourself mock projects, such as designing characters for a hypothetical movie. Make sure you go out and live a little. And don't get discouraged if you get rejected – it's bound to happen, but just keep trying.

" MAKE SURE YOU GO OUT
AND LIVE A LITTLE. AND
DON'T GET DISCOURAGED
IF YOU GET REJECTED. IT'S
BOUND TO HAPPEN, BUT
JUST KEEP TRYING "

Opposite page: Some character
sketches of Grocha, a wise witch
– just watch out for her third eye

This page: Design explorations
for a testicular cancer awareness
campaign – the guys on the
right were the final design
© Patients & Purpose

nad & tad

HOT ON THE TRAIL!
JUSTIN RODRIGUES

I'm here to walk you through how I go about designing a character based on a brief with a few specific words for inspiration. The client provided me with this set of words: elderly gentleman, detective, revelation, evidence, and humor. I have got to say, all of those things are right up my alley! I love detective stories from all periods and genres. In fact, some of my favorites are campy, buddy-cop detective movies from the 80s. In this tutorial, you'll see how I start with an obvious, easy solution and then begin to formulate visual ideas that will not only satisfy the request, but will also be unique, specific, and interesting.

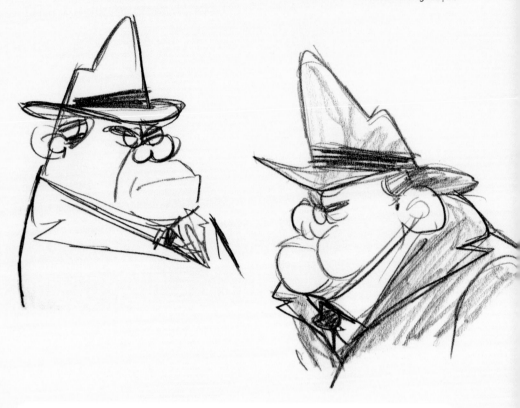

LET'S ROLL

I start any assignment with research, research, and more research! For this brief, my mind instantly goes back to hard-boiled noir detectives of the 1930s and 1940s. I love these stories, and think they are the most universal version of a detective. I make a Pinterest board of stills from old movies starring actors such as Humphrey Bogart, Gig Young, and Robert Mitchum. I even watch clips on YouTube – anything to get the ideas flowing. All this information adds solid ideas to my visual library, which I can use when I start sketching.

A TRIP FOR BISCUITS

The phrase "a trip for biscuits" means making a trip for no reason, which I definitely don't want to do here. While I sketch, I constantly think of the story I want to tell. Since I'm not really a writer, I do a lot of my thinking through my sketches. I never settle on just one drawing or idea. At this stage I just iterate sketches; I try to exhaust my mental databank by keeping it rough and quick. I sketch only to explore story and character rather than to land on a final illustration. Sometimes I draw the same pose or design multiple times from scratch to improve upon it. Often, I'll leave a rough drawing I like for later to clean up and paint digitally.

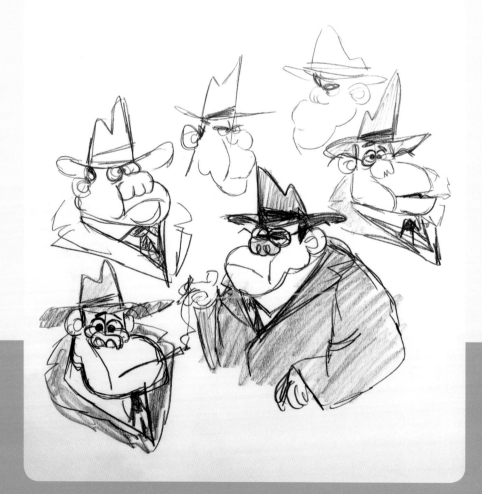

This page (top): My first two sketches after reading the client's brief

This page (bottom): This is what a typical page of rough sketches looks like for me

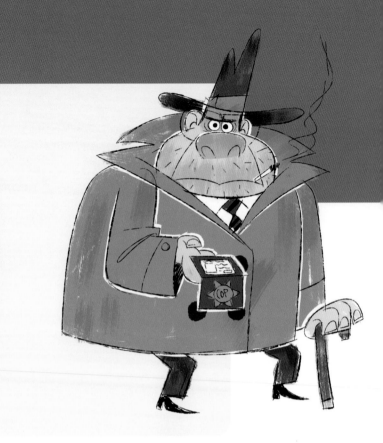

PUT THE SCREWS ON IT

I start to run out of ideas here and see there is only so much you can do with a 1930s or 40s noir detective. It starts to feel derivative, boring, and obvious, and I realize I have not fully thought through my idea. The possibilities are endless! I have relied too heavily on limited research and preconceptions of what a detective is. When this happens, I try to come at the problem from the opposite angle, to help me break away from the current direction. For this brief I draw mostly on paper with pencil, maybe a little ink, or colored pencil. When I am working digitally at this stage, I tend to either throw out ideas and drawings too fast *or* my pace slows, and I get bogged down.

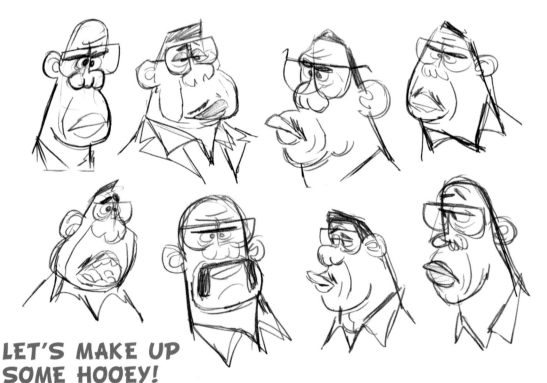

This page (top):
The original design progressed a little further before I decided to switch tracks

This page (bottom):
Some initial head sketches from the inception of this idea

Opposite page (top):
One of my sketches after leaning into the 80s direction

Opposite page (bottom):
More exploration of my 80s-inspired detective

LET'S MAKE UP SOME HOOEY!

I decide I want to come at this from a different angle and think about other detective stories I enjoy, such as *Beverly Hills Cop*, *Lethal Weapon*, and *Miami Vice*. I love those 80s vibes, so I head down that road. Again, I just iterate and draw as many different versions of this idea as I can.

Maybe the story is set in present time and our hero was a hotshot detective in the 80s who doesn't want to give up his glory days? Maybe he still drives his 1986 Ferrari Testarossa? Maybe *Miami Vice* influenced him to dress like that in the 80s, and he still does? Now the ideas flood in...

SHOOT THE WORKS

At this point I believe I have settled on a direction. I like to think of this process as sitting in an optometrist's chair. The idea starts out fuzzy and each drawing is like lowering one of those lenses, as little by little the idea becomes clearer. As I draw, I think of specific moments, not just static hero poses. After all, I am designing a *character*, not creating an illustration. To be honest, at this stage I'm not concerned about the final image – I just want to convey *who* this character is. This helps me focus on the story and not just design for design's sake. I imagine this playing out like a movie in my head. The story evolves as I draw, and I think about the words of the brief. What is the evidence? What case is he trying to solve? Where does the revelation come in?

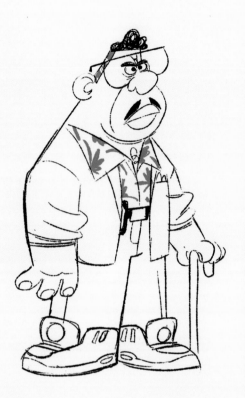

LIFE DRAWING

Life drawing is extremely important for both scholarly and technical reasons. It informs anatomy and structure, which are extremely important from a purely artistic standpoint. Drawing *from* life, however, is more of a study of character. Drawing at a café or restaurant, or any local space, makes you slow down and pay attention to the people who populate the real world. It lends specificity to the characters we have to create, and helps them feel authentic to your audience.

BANANA IN THE TAIL PIPE

I continue to visually explore the 1980s-detective theme – he wears a suit jacket with the sleeves rolled up, and a Hawaiian shirt. Maybe he wore Reebok Pumps and still does? I explore shapes and costumes to try to get some ideas down. I also think about details:

- How old do I want this character to be?
- How limited is he by his age?
- Does he have a cane?
- Can I incorporate that into the story?

All of these specifics inform the visual design of this idea. The more precise your answers to these questions, the more successful the character design will be.

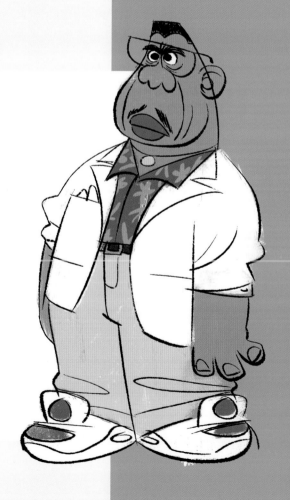

BEING A PROPER SNOOPER

As I dive into specific details, I think more about the design of this character. These things usually happen organically and simultaneously. In this case I work from the general to the specific. Now that I start to narrow down on the specifics of the story, the design starts to come into focus. A lot of my designs so far are not necessarily reading as "elderly." I start to solve this new problem and draw on research and personal experience. I think about my own grandfather – his physical proportions and what he would wear – and start to incorporate that. Design is problem-solving and sometimes is almost like being a detective yourself. Answering one set of questions just leads to more questions.

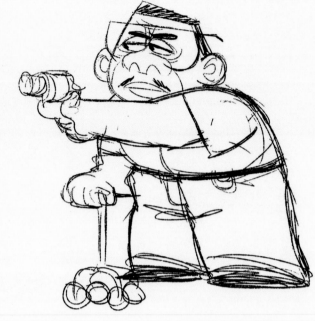

This page: Trying to incorporate more elderly aspects into the character

Opposite page (top): Sketching the moment he comes face-to-face with the 'perp'

Opposite page (bottom): In tropical prints and shorts, he is more "vacation" than *Miami Vice*

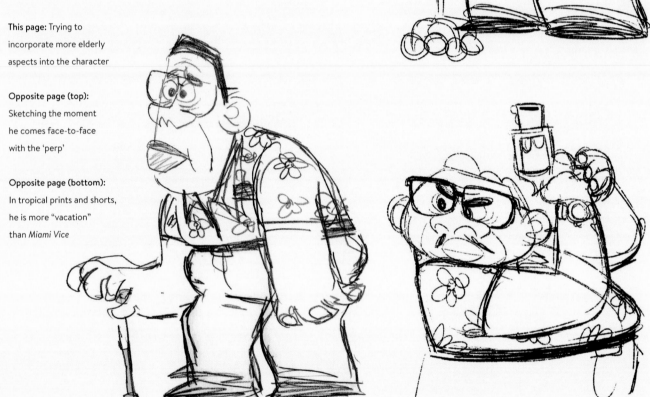

EXPERIMENT

I love to experiment with different mediums while in the design process. Experiment with different techniques to break out of your comfort zone. Try a paper collage or digital collage. When constructing a collage, you have to think in large shapes, which sometimes lead to happy accidents that can inform a final color or pattern. Or use ink or a large sharpie. There is something about the permanence of ink that makes you be decisive. Also the blunter the object, the less you can focus on detail, and the big picture becomes clearer and more refined.

MURDER ON THE HIGH SEAS!

As I explore this 80s, *Miami Vice*, tropical theme, I start to formulate an even more specific story in my head. What if our hero is a retired star detective on a cruise, when suddenly someone is murdered? In searching for the murderer, he discovers the ship's captain is smuggling illegal cargo to other countries – this can be the revelation. This change in storyline slightly changes my design direction. Now, instead of a suave 80s detective, I include tropical vacation wear. I incorporate shapes and proportions that make him feel more elderly and read more as an old man, such as hiking his pants up high, which shortens his torso. My grandfather was a short and stout guy so that is what I'm aiming for now.

DIG THE THREADS

Costume is an extremely important step in character design. I start to explore what a grandpa would wear on a cruise. I experiment with a Hawaiian shirt and linen pants, but that does not necessarily scream "detective." Do I give him a badge and a gun? I feel a little lost, and whenever that happens, I go back to my research. Now that I have my story completely nailed down, it's time to research specific costume details.

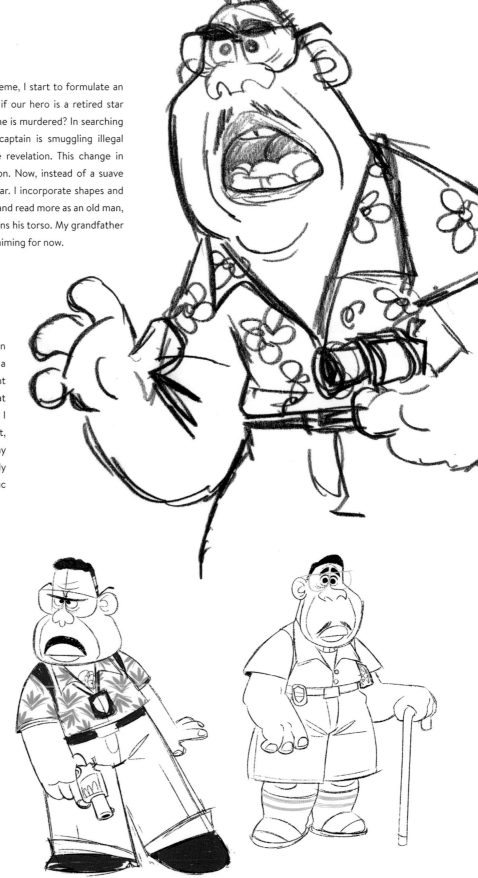

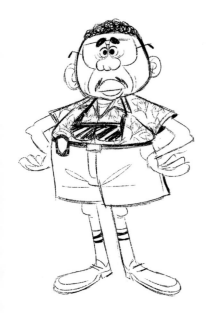

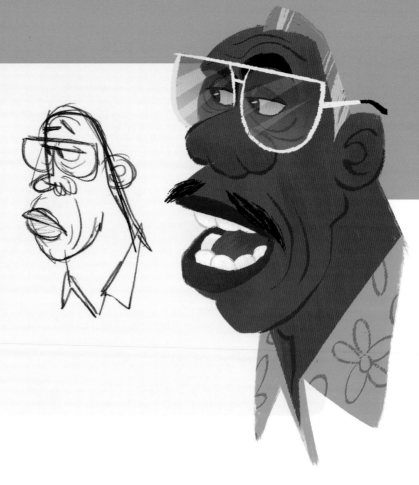

COLOR OF THE DAY

I have set up some parameters for my design, so go back to the rough sketches to identify any designs I can take further, and find this one. There were nice shapes and personality in this rough sketch, so I take it to the next step. Sometimes it is quick and easy for me to do a digital paint over one of my super-rough sketches. If I end up liking it I will flesh out the rest and make it something more permanent. I liked some aspects of this quick head sketch I did. The hair reads a bit military, which could work for a cop or detective, but he still feels a little too cool or tough.

"I START TO TIE DOWN AND EXPLORE MORE STORY-CENTRIC POSES"

HOT ON THE TRAIL

Completing everything I have thought about so far, I start to tie down and explore more story-centric poses. Some of the poses I roughed out earlier and liked, so I start to flesh them out while at the same time exploring proportion, costume, and expression. I still keep it rough and loose, even though it is not the particular design I end up choosing, but they get closer to the final design. Some of these are getting pretty darn close to what I ended up with.

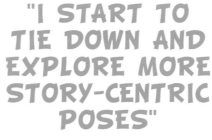

This page: A quick color composition on one of the head sketches I like from earlier in the process

This page (bottom): Story poses

Opposite page: Color exploration using colors from the earlier research

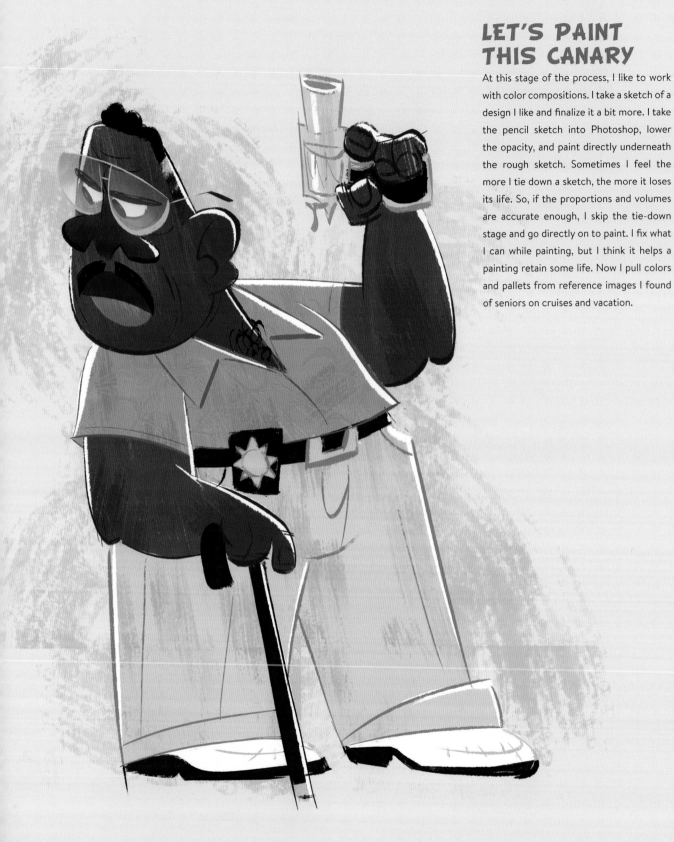

LET'S PAINT
THIS CANARY

At this stage of the process, I like to work with color compositions. I take a sketch of a design I like and finalize it a bit more. I take the pencil sketch into Photoshop, lower the opacity, and paint directly underneath the rough sketch. Sometimes I feel the more I tie down a sketch, the more it loses its life. So, if the proportions and volumes are accurate enough, I skip the tie-down stage and go directly on to paint. I fix what I can while painting, but I think it helps a painting retain some life. Now I pull colors and pallets from reference images I found of seniors on cruises and vacation.

CLOSING IN ON THE PERP!

As I draw over the rough poses, I stumble on what will be the final design. These poses were fun and interesting, and I liked the face and head design; I just needed to push the proportions and shape of the overall design. I widen out his hips and triangulate his body further. It took me a while to work out his legs – the designer in me wants to juxtapose his wide shorts with narrow legs, but I don't feel they would be able to support his larger body. I settle on thicker legs and feet to give him more stability and imply that he is a bit out of shape. Here, he is sneaking around rooms looking for clues, closing in on the perp!

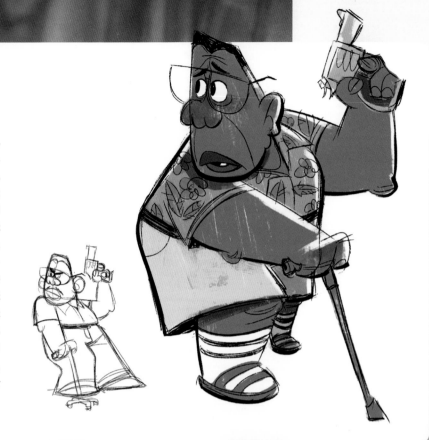

This spread:
Me, working on
the final design

This page (top):
Inspired by an earlier
sketch, this is the
first story pose using
the final design

IT'S JUST GOOD POLICE WORK

Once I settle on the "final" design, I want to create some story-specific poses. I use some of the roughs I liked and apply the new design to them. What would this character do while trying to solve a murder on a cruise ship? He would find a stash of illegal cargo in a store room, but because of his age, he relies on his cane to get down on one knee to verify what it is. And how would his use of a cane affect his ability to use his gun, especially if he hasn't used it in about 35 years?

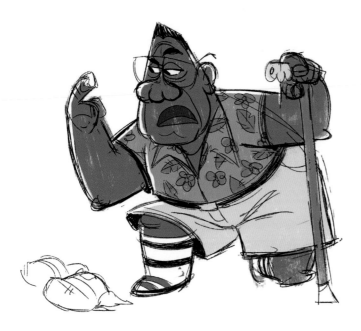

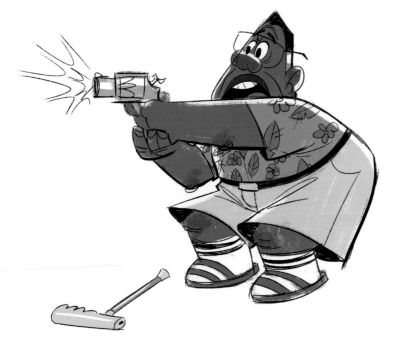

"MY GRANDFATHER ALWAYS HAD THESE PRESCRIPTION SUNGLASSES WITH GRADIENT LENSES, SO I GAVE MY CHARACTER THOSE"

A JOB WELL DONE!

Funnily enough, the poses came *before* the final painting. I wanted to do a "hero pose" of our retired detective, and this is the culmination of all the color compositions, style explorations, and rough sketches that came before. I take a rough sketch and do a tie-down drawing on top of it. Then I paint in the silhouette and, on top of that, add more and more details on different layers in Photoshop. I like the look of one of my earlier color compositions and decide to go with that. My grandfather always had these prescription sunglasses with gradient lenses, so I gave my character those. I also feel he wouldn't care about matching his socks to the rest of his outfit, so royal blue and scarlet red it is. He is back on top after a job well done!

This page (left): Breaking in the design with poses inspired by the story

Opposite page: The final hero pose, incorporating the special sunglasses my grandfather wore
Final image © Justin Rodrigues

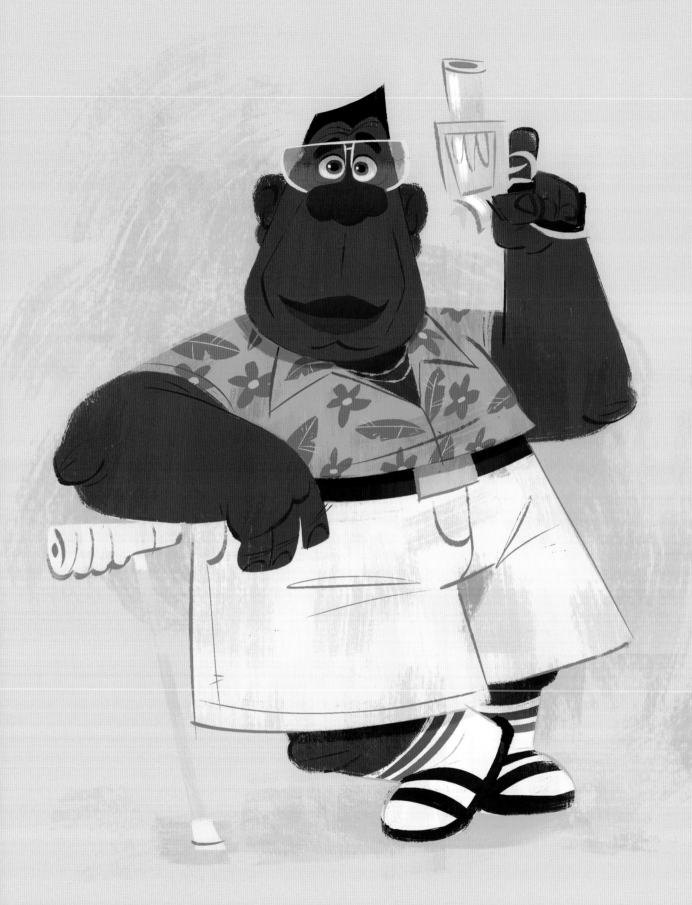

FEELING EMOTIONAL

FAUSTINE MERLE

In this article I will give you tips and advice in order to express the emotions "scheming" and "thoughtful" in characters. These two emotions are quite opposing but can both define the temperament of a character. I always begin with rough sketches on paper then I use Procreate to improve the drawings.

SCHEMING

CALCULATING FACIAL CODES

"Scheming" is a word often attributed to villains or mischievous characters. Because of this, the emotion is usually a mix of both angry and happy facial codes, like frowning eyebrows and big smile.

CONNIVING CURVES

A character playing with their hands can depict malice and manipulation. To portray this you can draw the fingers with curves and tension. Also a posture that is more curled up can show that the character is planning something and wants to keep it secret.

PRICKLY EXAGGERATION

In order to translate an animal's emotions, you can exaggerate their natural anatomy and attitude, and combine with human emotional codes. Emphasizing the sharp, almond shape of cats' eyes can imply intensity and sinister intentions, while claws and the fur around the eyes can be posed like fingers and eyebrows, and treated the same way as on human characters.

All images © Faustine Merle

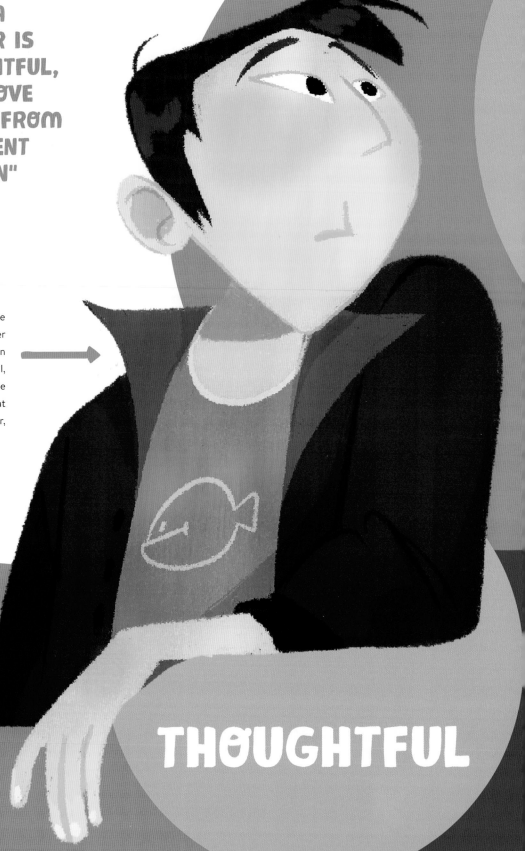

"WHEN A CHARACTER IS VERY THOUGHTFUL, THEY REMOVE THEMSELVES FROM THE CURRENT SITUATION"

FARAWAY GLANCES

To effectively convey a subtle emotion such as this, the character must appear to embody it. When a character is very thoughtful, they remove themselves from the current situation, so they might look away at nothing in particular, lost in thought.

THOUGHTFUL

INTERNALIZED ATTENTION

When thoughtful, the character's body needs to appear relaxed and stable, because the attention of the character is focused in their mind. Their shoulders could be down and eyebrows up, to imply the inner workings of their brain, while everything else appears stretched out and relaxed.

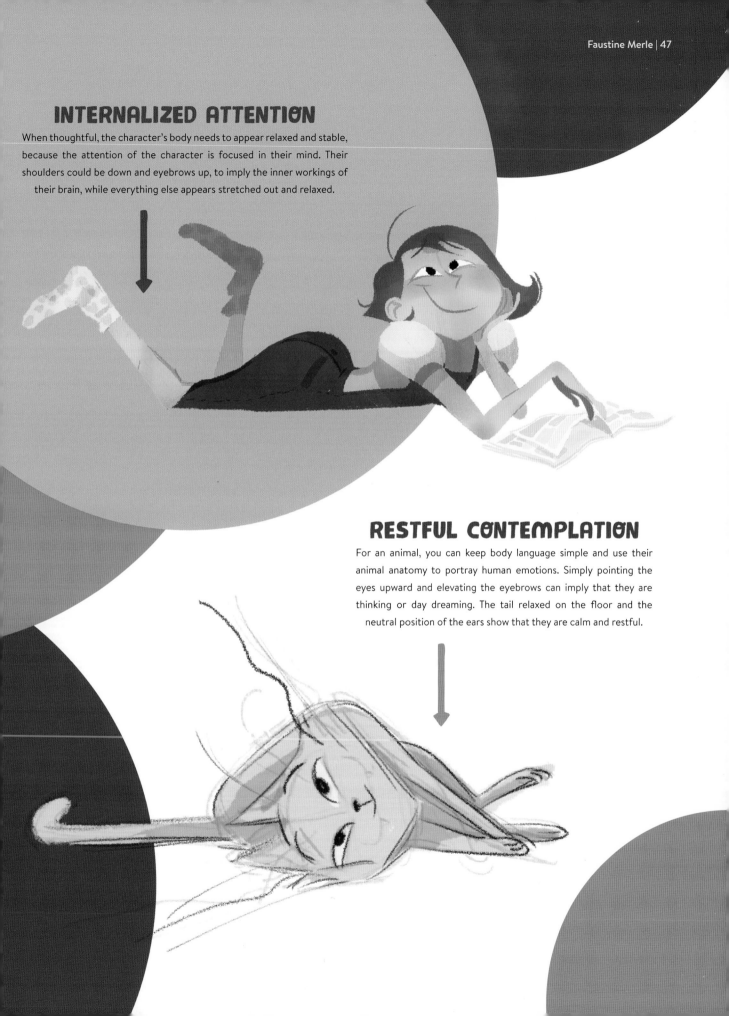

RESTFUL CONTEMPLATION

For an animal, you can keep body language simple and use their animal anatomy to portray human emotions. Simply pointing the eyes upward and elevating the eyebrows can imply that they are thinking or day dreaming. The tail relaxed on the floor and the neutral position of the ears show that they are calm and restful.

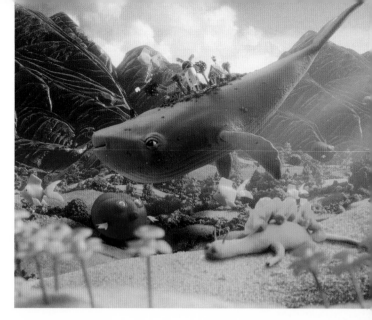

STUDIO SPOTLIGHT:
red knuckles

Company and Creative Directors, Mario Ucci and Rick Thiele, discuss how their desire for growth within the creative industry led them to open Red Knuckles studio. They tell us about their involvement in high-profile campaigns and unique projects, and how they view their studio as a creative collective.

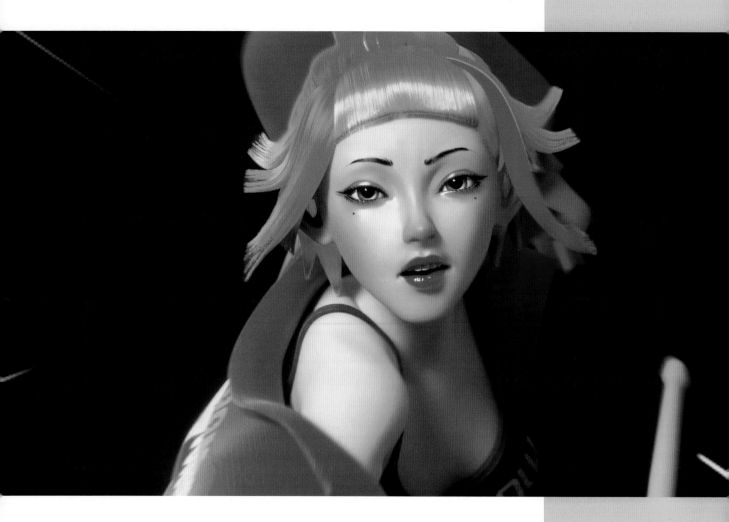

Hi Rick and Mario, thank you for giving us the opportunity to find out all about your studio, Red Knuckles. So, how did it all begin, and how have things evolved over the years?

We had both worked for big companies like The Mill, MPC, and Passion Pictures for many years, until we were at the point where we needed to grow further. We wanted to work with all kinds of different creatives and focus on our own projects at the same time – it just wasn't possible to do all of these things at once, or any of them at all. The only way forward was to set up our own studio and start being in control of what we did and where we went. In all honesty, it was a regrettable decision for the first few years. Starting a company with no backing and relying purely on yourself is not easy, but with

time and hard work we began to find our way – and we met many great people that wanted to get on the rollercoaster with us. It's now six years later, and we've worked on many incredible, award-winning projects, and we're continuing to grow.

What sort of projects do you work on, and do you have any preferences? Tell us a bit about your animated film, *Dark Noir*.

We mainly take on projects that are focused on character animation, in any style imaginable. *Dark Noir* was our first project and we had many great people believing in us to make that happen. It was a seemingly impossible project, budget and schedule wise, but we took on a small team and it ended up being some of the most exciting work we've done

This page:
Virtual band Rich
Boom's music video
© iQIY China

Opposite page:
Macca's Mini Games
character development
(character design by
Passion Pictures Australia)
© McDonald's Australia

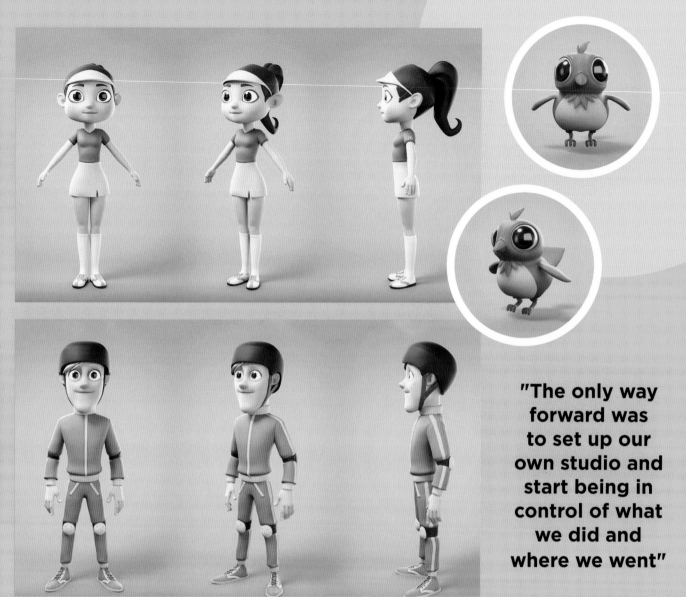

"The only way
forward was
to set up our
own studio and
start being in
control of what
we did and
where we went"

How many people usually work on a project, and what do each of them do?

It's hard to put an average down, because every project varies so much in terms of complexity. The animated advert for Swiss retailer Manor had about 20 to 30 people in total. We usually prefer to work with artists that can take on more than just one particular role, such as modelers that can also retopologize, and add UV and texture. Having semi or full generalists helps the process by removing pressure points between departments, and too much back and forth. Coordinators and producers for us are vital in keeping the peace and making sure the process becomes easier, which can be the opposite of what they do in other companies.

Tell us about the culture at the Red Knuckles studio, and the qualities you look for in potential team members.

We pride ourselves on being a creative space run by artists, for artists. There isn't a top-down approach in our studio; instead, we have a horizontal structure where everyone is treated in the same way, and expected to work on each project like it's their own. You can find Rick, Mario, and the production staff sitting next to the animators, interns, and whoever else is working with us at the time. The studio vibe is very positive and relaxed, and we tend to allow our artists to make up their own day. There isn't a specific model for a day in the office – it's really up to each one of the people working with us.

When assessing whether an artist will work well with us, we first look into their technical and artistic qualities, be it animation skills, compositing flair, or modeling ability. But once a person starts working with us it's very important for them to be easy-going, and to embrace autonomy and teamwork. A good sense of humor always helps as well!

This page:
Still from speculative trailer for
Full Throttle (original character
design © LucasArts, adapted
character design by Red Knuckles)

Opposite page:
Peperami "We Are Animal" television
commercial © Peperami

This page:
Stills and character design from a Dom.Ru advert (*character design by BAT*)
© Dom.Ru Russia

Opposite page:
Pilgrim's Cheese "Cheese of Your Dreams" television commercial (*character design by Adeena Grubb*)
© Pilgrim's Cheese

EMPLOYEE PROFILE

Name:
Clarisse Valeix

Job title:
Lighting and compositing artist

Education:
Master degree at *Supinfocom*

Website:
cargocollective.com/clarisse_valeix

Best bits of the job

I enjoy working on lighting and compositing as it allows me to master the image right from the start. I love to work on full CG projects and see the progress from the first concept to the final graded image; it's so rewarding. It's unusual to work on both aspects but I've been able to do it at Red Knuckles.

Challenges of the job

Working exclusively with a team of freelancers can sometimes be challenging, as each artist has their own background and method. There needs to be organization and trust to get everyone working together toward the same objective – but luckily those are things that Red Knuckles cultivates. The studio gives a lot of freedom to artists when it comes to workflow and solutions, and that can obviously lead to some disagreements, but on the other hand, it can be a real strength when it comes to creativity.

What advice would you give to budding animation artists?

Don't be afraid to work on new things – there will always be other artists ready to help and teach you. Be curious and keep learning!

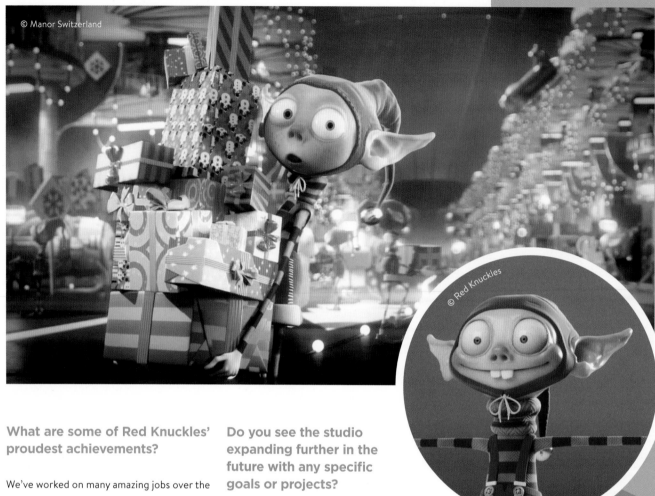

© Manor Switzerland

© Red Knuckles

© Red Knuckles

What are some of Red Knuckles' proudest achievements?

We've worked on many amazing jobs over the years and are proud of them all. Being able to tackle challenging briefs and make them come true, in a way where everyone is proud of what they did, is our main goal. Recent examples include the Peperami *We Are Animal* ad campaign, and an ad for Homebase, co-directed with Ozzie Pullin and produced by Partizan. We're also proud of the Pilgrims Choice campaign *Cheese of Your Dreams*, co-directed with Adeena Grubb, and *Maccas Mini Games* for McDonald's, produced by Passion Pictures Australia. Not to mention the Manor ads produced by Passion Pictures Paris. We enjoy taking on mixed-media projects like the music video *Sending This One Out* for DJ Loco Dice, where we mixed 2D and 3D media. The more you blend artists of different backgrounds and styles, the more interesting the outcome. Our recent speculative trailer for cult classic game *Full Throttle* doesn't look half bad either...

Do you see the studio expanding further in the future with any specific goals or projects?

We love working on creative projects where we can push the bar, whether stylistically or in narrative terms. We also enjoy collaborating with other production companies, who approach us because of our artistic ability and technical knowledge – they know we can make a vision come true. We're also developing personal projects dealing with long-form narrative content. We're very interested in combining animation with other media, like virtual and augmented reality, interactive platforms, and mobile apps. Nowadays there are many exciting new ways of using animation.

This spread:

Character development for Manor advert (Santa design by Kevin Grady, Elf design by Peter de Sève)

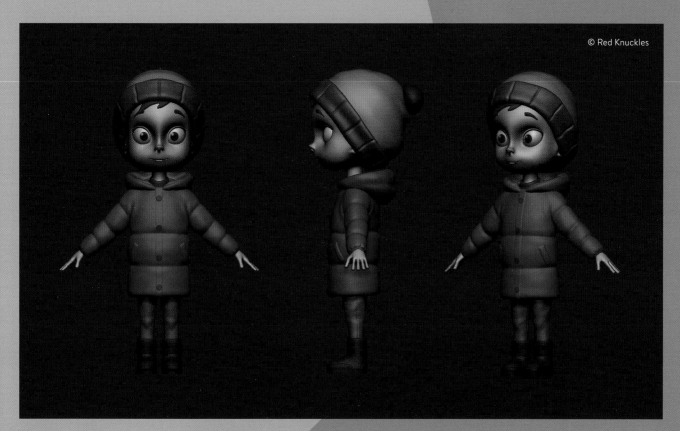

© Red Knuckles

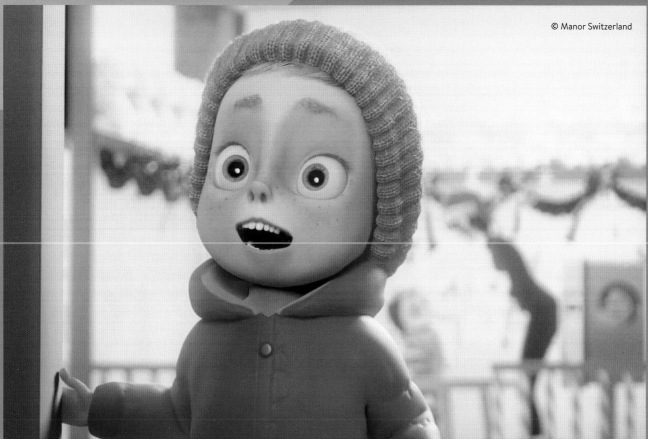

© Manor Switzerland

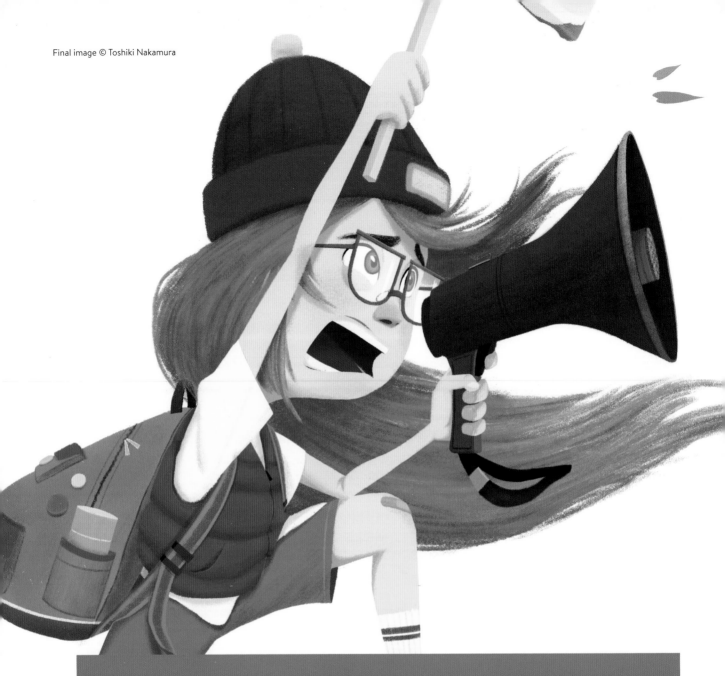

PROTEST YOUR FRUSTRATION
TOSHIKI NAKAMURA

In this tutorial, I demonstrate my process for designing a character who is feeling frustrated. Climate-change protests have been taking place all over the world, and my brief was to design a "frustrated protester." I know from the start that the design needs to demonstrate a range of feeling that lies beneath the surface of the frustration. I decide to design a girl around the age of 13, who is participating in an after-school protest.

DO YOUR RESEARCH

When given a brief, you will always need to do some level of research. Even if you are familiar with the subject in some way, do your research and find references. Writing down your ideas for the character will be helpful when you start looking for visual references. This phase might take some time, but do not ignore it – references will ensure you avoid straying from the brief, saving you time in the long run. You might also be surprised by what you discover during your research. Mind-mapping (see right) is a fast and effective way to help you understand your character in depth.

"YOUR FIRST IDEAS MIGHT HAVE SOME POTENTIAL, BUT DO NOT GET TOO ATTACHED TO THEM"

KEEP IT LOOSE

After I compile the research, I begin to draw. This step is different for every artist – some prefer to do thumbnails (exploratory sketches) while others start designing straight away. Regardless of your preference, keep it loose and quickly get your ideas down on paper. Eight to twelve sketches is an ideal number, but if you want to draw more, that's great! Your first ideas might have some potential, but do not get too attached to them.

This page: Free and quick sketches, as it is just the start of the design process

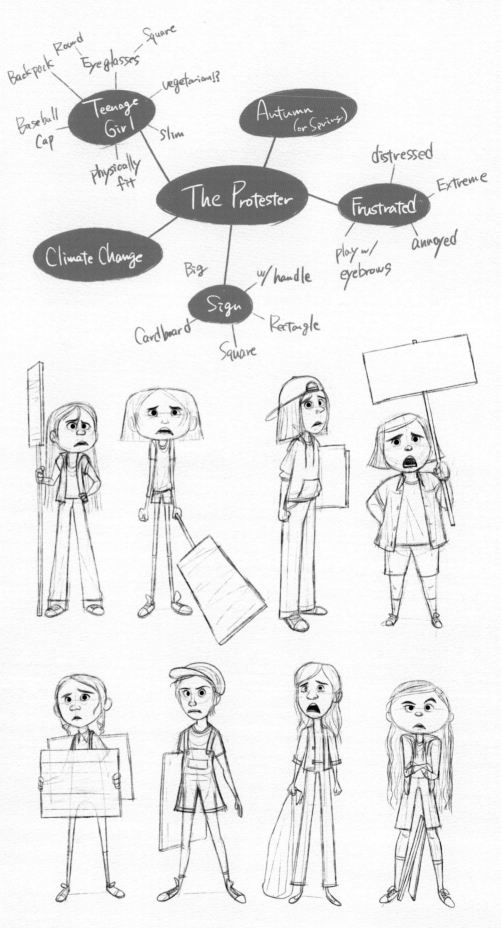

VISUALIZE SHAPES

Next I select my preferred thumbnails and highlight their shape language, to help decide which one to take forward to the next stage. Strong shape language is a common way for artists to help the viewer recognize a character instantly and begin to understand the personality. I have a certain direction in mind for this character, and decide on a slim body type.

This page: Four of my initial sketches with simple shape language shown in red

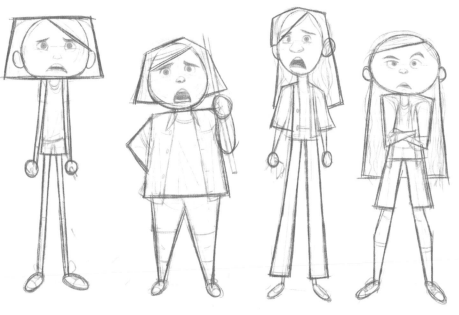

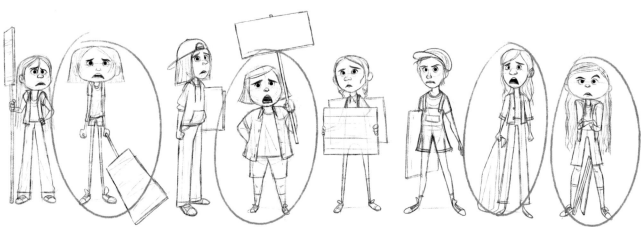

SHAPE LANGUAGE

For this character, the shapes used communicate several important characteristics:

"STRONG SHAPE LANGUAGE IS A COMMON WAY FOR ARTISTS TO HELP THE VIEWER RECOGNIZE A CHARACTER INSTANTLY"

Square body suggests a solid and dependable character

Long, thin shapes hint at vulnerability and youth

Circular faces convey youth as well as innocence

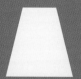

Trapezoid-shaped hair is no-nonsense and practical-looking

NARROW IT DOWN

Now, using the basic shapes of the slim body types from the previous step, you can explore more options for the character. However, do not limit yourself to those specific shapes. Keep the initial sketches loose, and play around with poses if necessary. Different gestures can give a character an entirely different story and persona. Experiment through the shape language identified – go with the flow and have fun with it. I want to continue with the idea of an angrily frustrated character, so I produce another round of exploratory sketches.

This page: Sketches with various poses and facial expressions to create contrasting moods and emotions

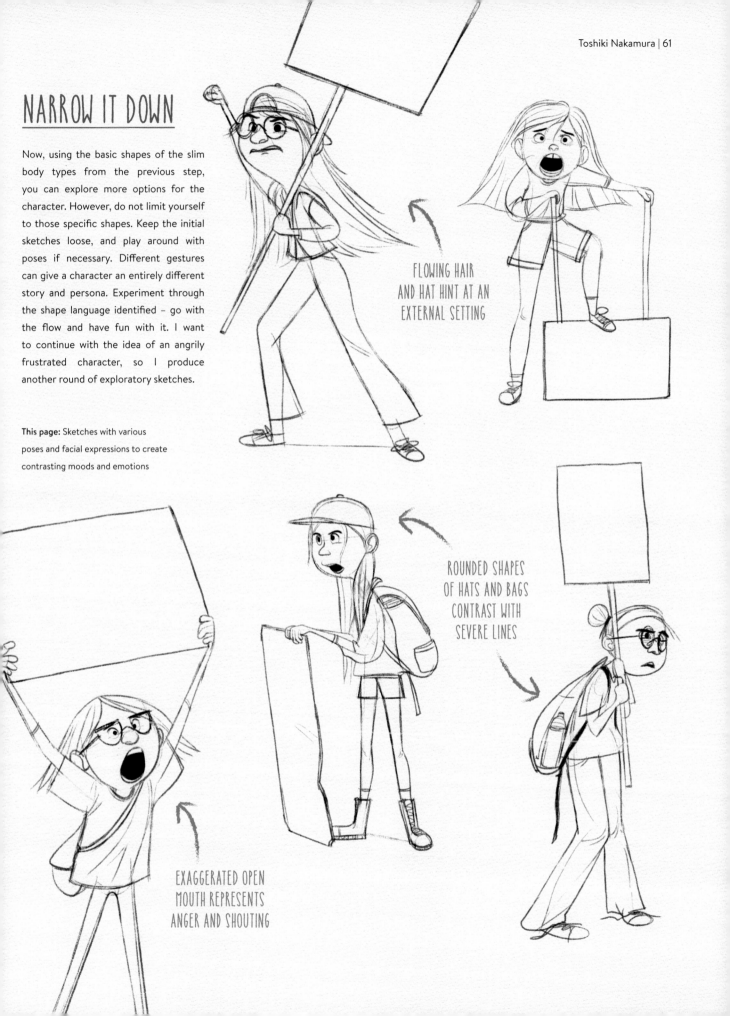

FLOWING HAIR AND HAT HINT AT AN EXTERNAL SETTING

ROUNDED SHAPES OF HATS AND BAGS CONTRAST WITH SEVERE LINES

EXAGGERATED OPEN MOUTH REPRESENTS ANGER AND SHOUTING

ACTING OUT

Acting is absolutely essential to storytelling, so I nail down the concepts from the previous stage. I want to find the right character in a pose that accurately illustrates their personality and back-story. In addition to storytelling, a successful pose can be a clear sign to the audience of what the character is feeling. I am torn between an energetic character and a subdued one. Decision-making is often the hardest part of the process, so try to get some feedback on your designs.

PUSH THE SHAPES

Create a unique, instantly recognizable character by pushing the proportions to create an interesting appearance. Use simple shapes to test different combinations – these will affect the personality of the character.

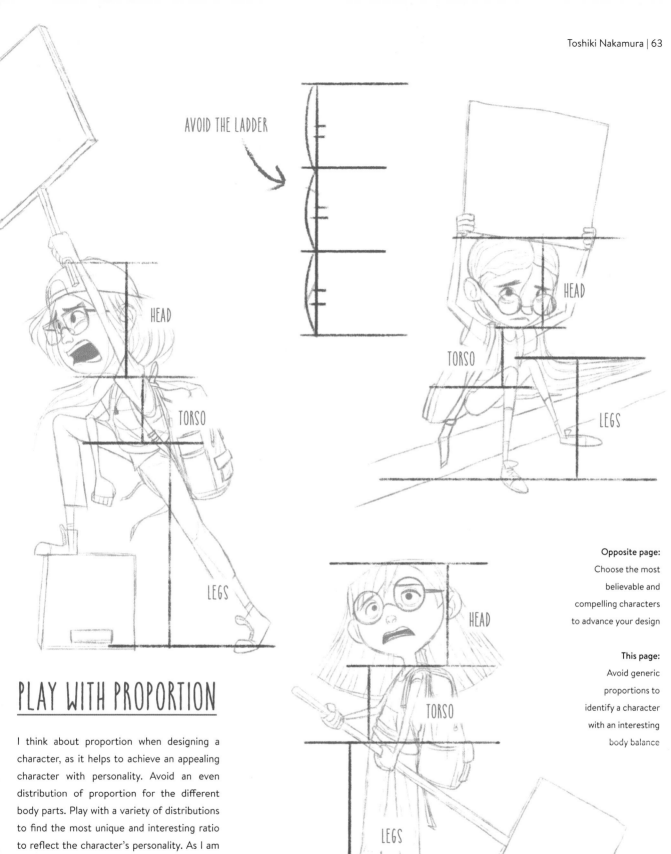

AVOID THE LADDER

HEAD

TORSO

LEGS

HEAD

TORSO

LEGS

HEAD

TORSO

LEGS

PLAY WITH PROPORTION

I think about proportion when designing a character, as it helps to achieve an appealing character with personality. Avoid an even distribution of proportion for the different body parts. Play with a variety of distributions to find the most unique and interesting ratio to reflect the character's personality. As I am following a specific body shape from an earlier stage, the character in each pose has almost the same proportions. However, if you dislike the body shape at this stage, feel free to experiment with the shapes and sizes.

Opposite page: Choose the most believable and compelling characters to advance your design

This page: Avoid generic proportions to identify a character with an interesting body balance

STAY POSITIVE

When the viewer sees only the silhouette of your character, they should be able to tell what it is. I flood-fill my sketch with a dark colour to hide the facial expression and other details. This allows me to see if the pose is working, and is also a good way to check the balance between positive space (dark areas) and negative space (non-dark areas). At this stage you can change the design to ensure the silhouette is as recognizable and powerful as possible. I choose the character that is standing with knee bent and plaquard held high to take to the next stage.

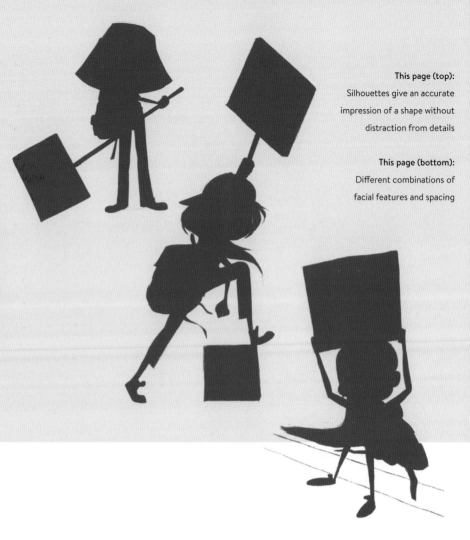

This page (top):
Silhouettes give an accurate impression of a shape without distraction from details

This page (bottom):
Different combinations of facial features and spacing

FACE YOUR AGE

You can create many personalities simply by changing facial structure. The placement of each feature can define factors such as age and ethnicity, so keep this in mind when constructing the face. My character is around 13 years old, so I want to create childlike features. If you want your character to be relatable and believable, it's important to do your research and find a way to incorporate certain features into the design. Don't be afraid to push yourself and go beyond your comfort zone. It's easier to go too far and pull back the stylization than it is to keep pushing it forward.

HERE THE DISTANCE BETWEEN LOWER LIP AND JAW IS TOO WIDE – IT CAN BE NARROWER ON YOUNGER CHARACTERS

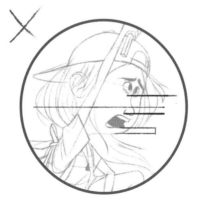

HERE THE DISTANCE BETWEEN NOSE AND EYES IS TOO WIDE – THIS CAN ALSO BE NARROWER ON YOUNGER CHARACTERS

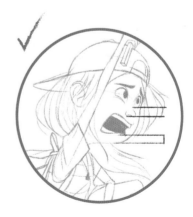

THESE ADJUSTMENTS HELP MAKE THE CHARACTER LOOK TRUE TO HER AGE

HOW CAN I PUSH
THE DESIGN?

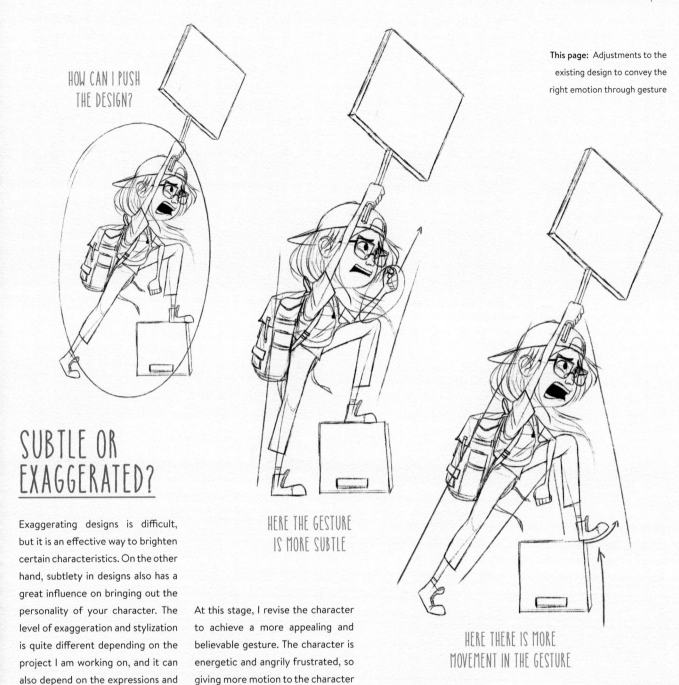

HERE THE GESTURE
IS MORE SUBTLE

HERE THERE IS MORE
MOVEMENT IN THE GESTURE

SUBTLE OR EXAGGERATED?

Exaggerating designs is difficult, but it is an effective way to brighten certain characteristics. On the other hand, subtlety in designs also has a great influence on bringing out the personality of your character. The level of exaggeration and stylization is quite different depending on the project I am working on, and it can also depend on the expressions and poses of the character.

At this stage, I revise the character to achieve a more appealing and believable gesture. The character is energetic and angrily frustrated, so giving more motion to the character will convey that intention.

IMPORTANCE OF AUTHENTICITY

When designing, it is important that the visuals are believable to the audience. Think about what makes the character authentic and convincing. Authenticity can be related to many of the aspects you portray in design, such as race, culture, religion, and clothing. This may seem like a small part of character design, but is something you cannot and should not ignore. Pay attention to who your character really is and their story, do the research, and incorporate what you find into your designs in a distinctive way.

HAIR AND WARDROBE

Physical shape is what you often first consider, but the final silhouette is also affected by what a character wears. Costume design is a fun part of the process, as there are so many options, but authenticity is key. No matter who your character is, making them believable and appealing to the audience is paramount, so I research what younger teenage girls wear to ensure this character looks authentic. Hair is also an important defining feature, and I use the motion of the long strands to create a more dramatic feel.

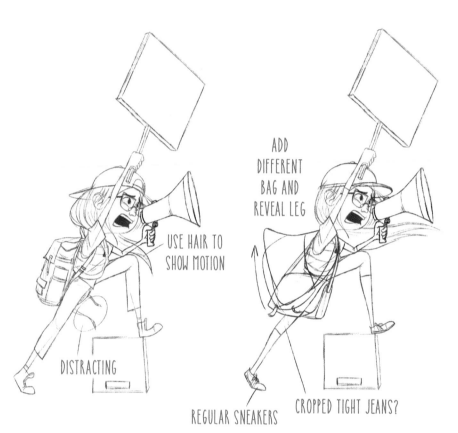

USE HAIR TO SHOW MOTION

DISTRACTING

ADD DIFFERENT BAG AND REVEAL LEG

REGULAR SNEAKERS

CROPPED TIGHT JEANS?

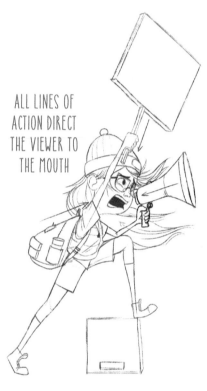

ALL LINES OF ACTION DIRECT THE VIEWER TO THE MOUTH

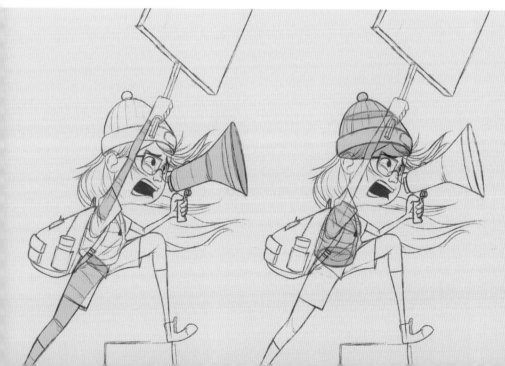

DIMENSIONALITY

When you draw on paper or digitally, the result is naturally two-dimensional. Whether you work on 2D or 3D projects, it is necessary to understand the character within a 3D form. To help with this, draw construction lines under the sketches to gain a better understanding of the volume. There are ways to indicate the volumes such as wrinkles, folds, and overlaps in fabric. When you move onto the value and coloring stages, adding shadow will also help with seeing things three-dimensionally.

CHECK THE VALUE

If you are new to working in color, I would recommend working in grayscale first. If the values are wrong, the color will not be as effective. You can go straight into adding color, but I would highly recommend frequently checking the values to ensure they are working. In this case, the face and stance should be the focus, to ensure the energy I created in the previous steps has the impact needed, while still being a cohesive design.

Opposite page (top):
The details of clothes might affect the final silhouette

Opposite page (bottom):
Cylinders reveal the volume of your drawing

This page (top):
Establishing the most effective combination of values

This page (bottom):
I decided the season would be fall, so choose earthy colors

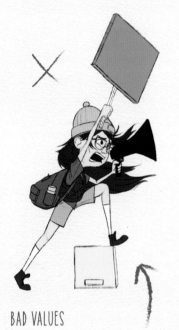

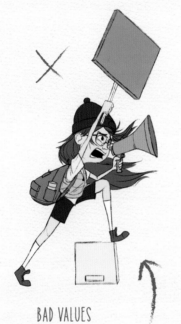

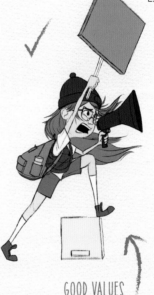

BAD VALUES

The light hat fights with the face for attention, while the dark colors used in the hair, bag, and sweater mean detail is lost around the body.

BAD VALUES

The lighter tones in the torso of the figure lack focus and contrast, making the viewer work harder to quickly read the image, while there is very little contrast between the hat, hair, and bag.

GOOD VALUES

Contrast around the face makes it stand out, while the very pale shirt keeps the viewer's eye on the top half of the character, where the head and hands are in motion.

COLOR

I generate different color schemes to see clearly which works and which doesn't. You can create color schemes in a million ways, but a good place to start is using inspiration from the character's personality and back-story. I usually generate two to three color schemes that are completely different. Sometimes I generate color schemes but then have no idea how to use them within the piece, and in that case I discard them – it is best to keep your selection smaller with fewer options to choose from.

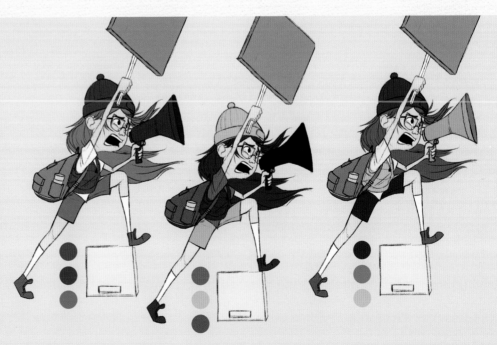

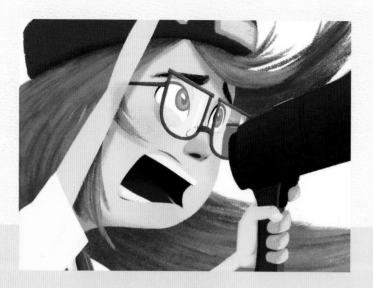

ON OR OFF?

Toward the end of the process, I experiment with our protestor's glasses – maybe she doesn't need them? But in the end, I decide they add to the story and characterization, so they stay.

DETAILS ADD CHARACTER

Once the color scheme is decided, it's time to start painting! At this stage, I add any other details I think will offer value and insight into the character's personality and back-story. However, too many extra features can sometimes overwhelm the character and hide your initial intention, so be careful what you add. A small element can be enough to help sell the character and their personality. In this case, I add text to the sign and a small band-aid on her knee.

IDEAS TRASH CAN

In the early stage of mind-mapping, I considered developing an older character to provide a wider variety of shapes and features to characterize. However, a teenager felt like a better fit with the brief. I also thought it would be a challenge for me to create an older character with an exaggerated and stylized body type.

This page (top):
Subtle details can add great narrative to a character

This page (bottom):
Think about the environment in which you place your final design – she is ready to protest!

FINAL TOUCHES

Now the character is finalized, I add a little more story to the image. Adding props or other characters will help the audience understand the narrative of your concept. I have decided to add a simple background. Since there is already movement in the hair, I have added some leaves that are being blown around in the wind. If I were to develop this character concept further, especially if it were for a portfolio, I would create turnarounds and sketch some more "loose" poses. Maybe I would even create some other protesters to show the variety of shapes and personalities.

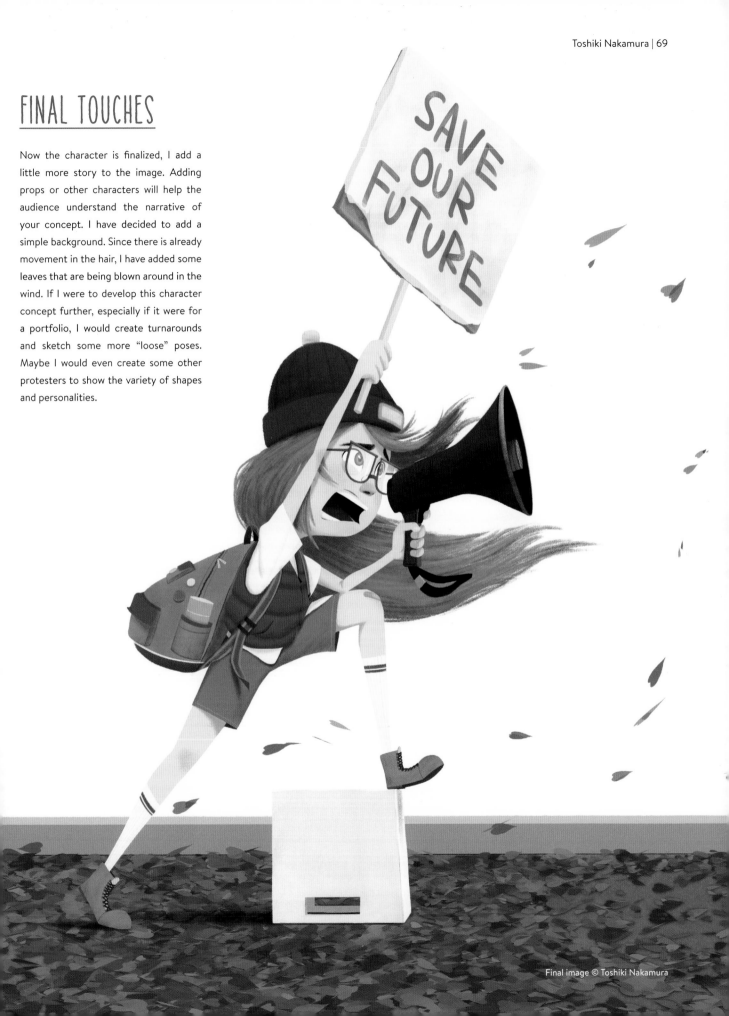

Final image © Toshiki Nakamura

CHARACTERIZE THIS:
SHY BLOSSOM
ELÉONORE PELLUAU

I was tasked with the creation of a unique and original character based on the theme "Shy Blossom." I immediately loved the brief, as I love all things natural – especially flowers. The possibilities are endless thanks to the multiple colors and shapes of flowers. I also find the concept of a shy character very interesting to create, as it offers an opportunity to give the character a hidden story. For example, how did they become shy? Have they always been shy, or is it a reaction to an event? Through this process I will show you how I approached this task, and how you can approach similar short briefs to create intriguing new characters.

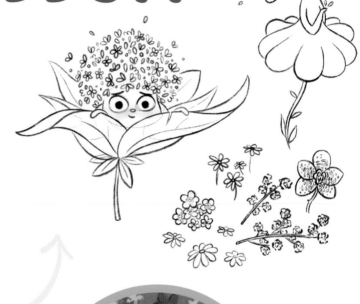

RESEARCH

At first, I undertake visual research to get an idea of which flowers to use as reference for my character. I also look at references of shy characters. For this particular brief, it's important to look at a range of different colors and shapes of flowers as this will help give further personality and believability to the character. Find a shape and color palette from your research that you enjoy and you feel best meets the brief.

FLOWER POWER

After considering which flowers might work best for this design, I choose mimosas and forget-me-nots as I like their delicate aesthetic, which connotes a quiet beauty and sense of shyness. When combined, they also allow me to create thick hair, which brings a feeling of protection and softness to my character – further reinforcing the character's gentle temperament.

PERSONALITY

The details and shape language of a character design are very important, as they define the nature of the character. I choose a rounded face shape and add a slightly blushing expression to correspond with the brief. I also integrate elements of the spotted orchid to indicate the fragility and exotic beauty of the character, and I make the ears flower-shaped to reinforce the floral theme.

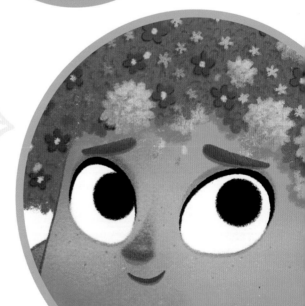

CHARACTERISTICS

To ensure the body language of the blossom accentuates her shy personality, her hands meet behind her back. My character is a small, fragile flower who "wears" a daisy skirt decorated with small bouquets of forget-me-nots. She also wears mimosa bracelets on her arms. These details show other aspects of her personality, perhaps she likes to present herself well to others and look her best?

STORYTELLING

The stem plays an important role in this particular design – I shortened it in order to show that the flower is very young. This portrays her innocence and reinforces her shyness, as she is still relatively new to the world. Of course, you can create a different storyline by giving your character different characteristics. Perhaps they are older? Not as pretty as the others? Take time to consider what story you can tell.

THE BLUSHING BLOSSOM

The final design is finished. Through the pose and the shapes chosen, the character is imbued with the feeling of shyness. Having faith in your character and believing their story will help you convey their feelings more effectively to the viewer. References are important when creating a new character, but don't forget to inject them with unique characteristics. The details will make all the difference and allow you to understand the character. Most importantly, have fun! Creating fun new characters like shy flowers should always be enjoyable!

All images © Eléonore Pelluau

MEET THE ARTIST:
LOBÓN
LEAL

Character designer, illustrator, and comic artist Lobón Leal teaches character creation and digital illustration at ESDIP in Madrid, Spain. In his spare time, he enters comic contests and fairs, and pursues personal projects including developing his new book.

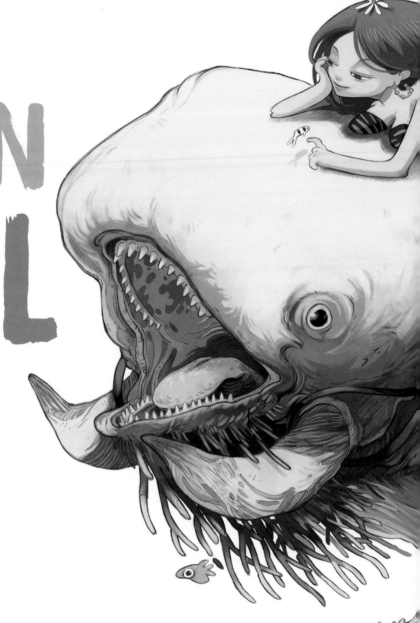

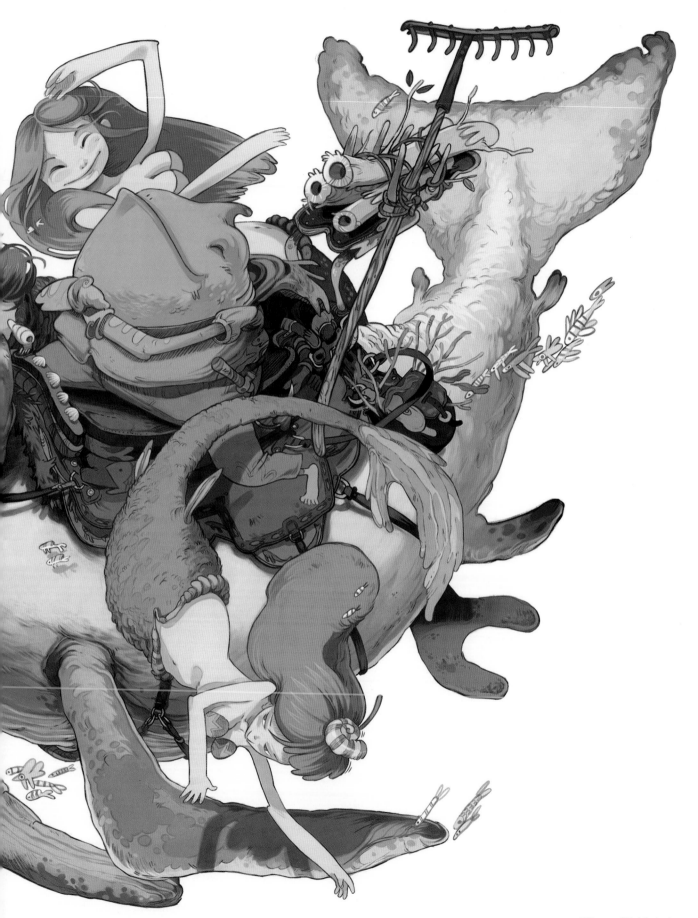

Hi Lobón, thank you for speaking with the team at *CDQ*. You teach art at ESDIP, so could you tell us about your own creative education and how you got to where you are today?

I had always known, since I was a young child, that I wanted to be an illustrator. I went on to study at art school and I graduated from the Complutense University of Fine Arts in Madrid. Although I devoted my college years to painting, when I finished my degree I decided to specialize in comics and illustration. Like most people within this field, I started off as self-taught. I did have the great opportunity of studying a master's degree on graphic creation at ESDIP, where I was taught by incredibly talented teachers and progressed my skills. I currently split my time between my professional work and teaching digital illustration at ESDIP.

How did you teach yourself illustration and comic-drawing skills? Do you follow any specific YouTube videos or other online resources?

I started by copying my favorite characters; I have far too many notebooks filled with Goku. I then bought a book on animation, which helped me work out the internal construction and shapes of characters. I spent time practicing drawing volumes, without details, for a long time until I could develop the characters in the poses I imagined. I started comic illustration when I was older. It was different because although I had read a lot about how to draw comics, when it came to it I could not achieve anything on my own. It wasn't until I met Jose Robledo, a great professional in the field who became a dear friend, who taught me in a very practical and orderly way. He helped me lay the foundations in regard to narrative, script, and the structure of comics. Now, I spend most of my time working within comic illustration. For a few years I have been immersed in developing, writing, and drawing *Samhain*, my own story.

"FOR A FEW YEARS I HAVE BEEN IMMERSED IN DEVELOPING, WRITING, AND DRAWING SAMHAIN, MY OWN STORY"

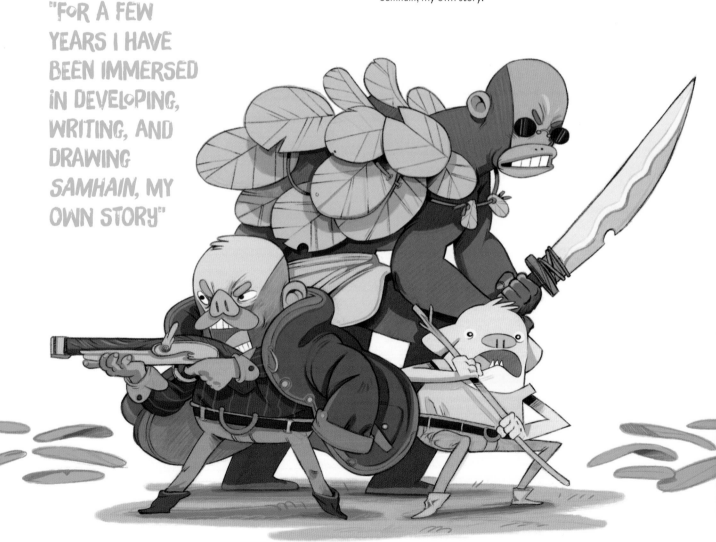

This spread:

Concept art for
my comic, *Samhain*

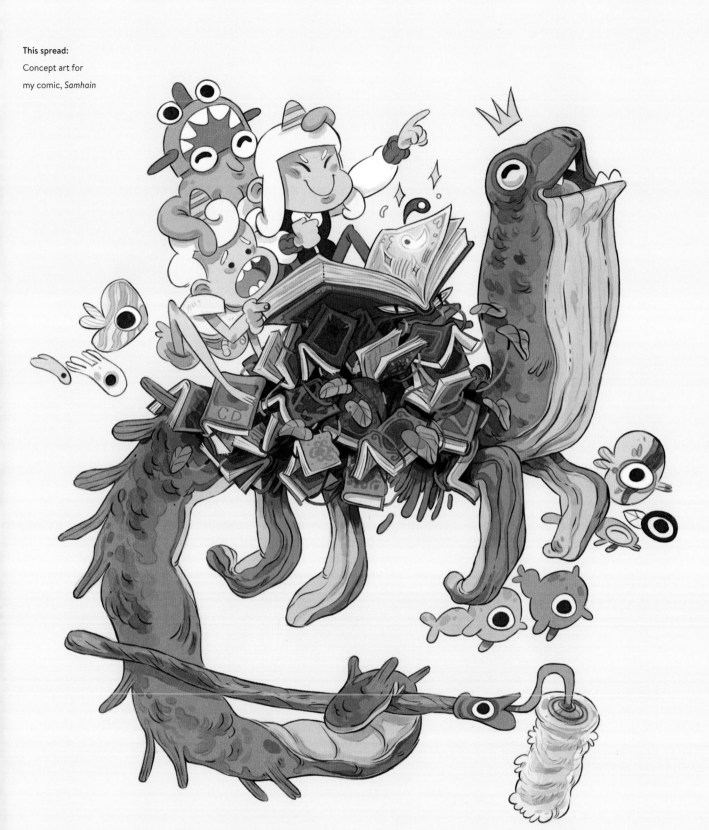

This page:
An illustration
for a character-
design challenge

Opposite page:
The Ink Smoker

You originally trained in Fine Art – what attracted you to character design and digital illustration?

Making the move from Fine Art to animation and illustration was a relatively easy one. I have always enjoyed and revelled in how real a fictional character can become to the viewer or reader. In a way, whether a character is animated or illustrated, they become someone familiar to us and we carry them with us. We are drawn to their story and grow with them. Characters become icons that leave a mark for generations to come. I have always liked to write and create the stories behind my own characters, to imagine beyond what is presented on the page – it helps me continue to enjoy my work.

As for digital illustration, like most artists I started traditionally and moved along with the field as it became more digitized. My training had been totally traditional, so teaching digital illustration was a challenge at first, for which I am now very grateful. In my classes I like to point out the differences between digital and traditional, which is blurred by the tools we use today.

What does the blurring of digital and traditional art mean to you?

Nowadays, with digital tools, you can get the same graphic result and the same resources as with traditional techniques – and for an illustrator that implies an unlimited amount of creative possibilities. I prefer to work with digital media, as it's faster and easier for practicing techniques. It also depends on your style and what kind of commission you are working on. Right now, in comic illustration, working with traditional materials would not be very cost effective due to the high price of traditional materials. But one traditional media I will always use is my sketchbook – I always have it with me. Although I work digitally for my main projects, my sketchbook is full of ideas. It is where I experiment with new shapes and designs.

Your designs are often high-energy, depicting characters captured in engaging action shots and poses. Is this dynamism another way to tell the story?

When I'm designing characters or illustrating them, I expect to convey their personality. Even if it is only a frame, a frozen instant, the pose that shows the most movement, gesture, and strength can achieve this. I have always liked to extend the line of action of the characters. In the first steps of the development of the idea, the sketches are very dynamic and expressive. Once I set them in a dynamic pose, I move on to studying and working with them doing a "tour around" and a model sheet.

I like magic and entropy, chaos and balance, all in invented worlds in which I can mix any concept or idea that comes to mind. I mainly write adventure and fantasy stories, without forgetting the vision of reality and reflection on current events.

I am very interested in the concept of magic realism; most of my stories are connected to nature and the environment in some way, too.

The process I enjoy the most, though, is developing the characters. I am aware of the universal archetypes of characters. There is a basic structure as a starting point, and then there are many possibilities of combining physical and personal characteristics. I have the most fun creating those combinations; I fall in love with them and invent thousands of situations for them to exist in. Many of the designs I work with are humanized animals, or characters that connect with the wild in some way.

Which part of the character design process do you enjoy most?

I really enjoy the first steps of the work; this is the most carefree phase in which I have fun inventing their stories and personalities. The development phase carries more weight. Most of my colleagues share the same feeling about the sketches and the final art. It is a delicate step where you evolve your story but try not to lose the strength and freshness of the first strokes. Another phase that I enjoy is playing with the character – designing variations, creating expressions, and exploring versions of the accessories. It is a phase that has to do with both the characters and their story. How they react to people, what their personality is – those are the characteristics that give characters life.

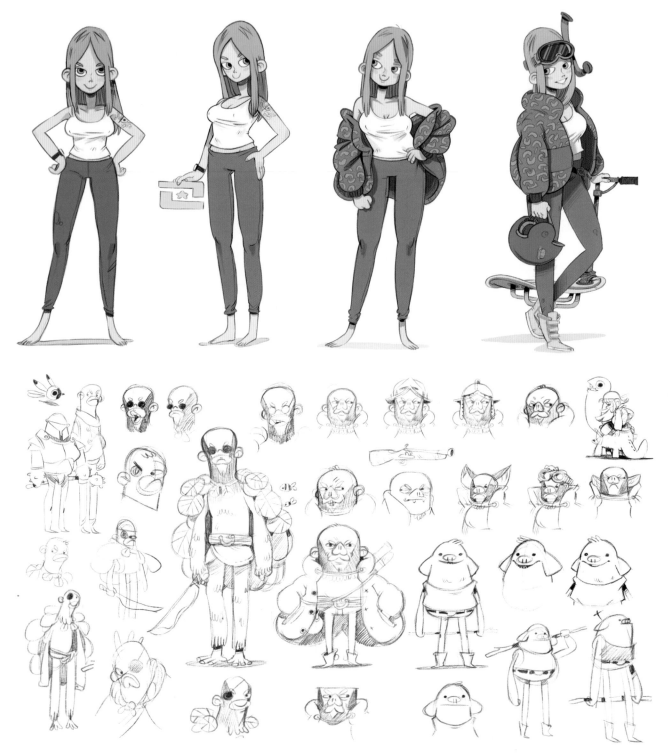

Who has had the biggest influence on your style of art?

The biggest influence on my work has been Akira Toriyama. I learned to draw by sketching his characters and, to this day, I still go back to his work to find answers – although I'm not as crazy as he is for machines. I am really into vegetation and plants, and that's the reason Hayao Miyazaki's films, with that vision of nature, have influenced me. Another great author that I always turn to is Eiichiro Oda. I am fascinated by all his characters. Finally, to add an influence outside the Asian artists, Cory Loftis is another significant influence. I would say that these four people have all helped shape my work to a some extent.

What advice do you have for artists starting out in the industry? Can you suggest any useful exercises or processes?

For all those who are starting, I am obliged to mention the cliché of drawing as much as you can. Copying, and making the effort to understand what you are copying. Analyze not only the drawing itself, but also all the internal constructions that are unseen – this will help you to begin to construct your own designs.

I would also advise, above all, that you must enjoy and have a good time in the process. It is sometimes frustrating, but with perseverance, you will be able to master it. I always say, this isn't a speed race but a long-distance one.

Nowadays there is high pressure and often frustration when it comes to the learning process; many people rush to try and strengthen their graphic style and increase productivity. Times are very rushed, and we forget that when talking about a technical skill, you need to have patience to develop your work. You have to consider that each person has a different maturation time and ability to internalize the knowledge they learn. That's why it's a long-distance race. Consistency is as important as the work itself.

I have some clear objectives for my own career. For example, right now I would like to focus on the process of getting my comic stories published and dedicate myself fully to that. If my work is recognized and begins to gain traction then things might change, but I'm not going to worry about something that is not in my hands, nor in the hands of anyone, due to all the factors involved for something like this to happen. So yes, right now I'm enjoying the journey, and that's what I like the most.

Opposite page (top):
Character design of
Alejandra Doble

Opposite page (bottom):
Visual development of
a character design

This page: Concept
art of *Ultragirl*

Tom Goyon | tomgoyon.com | Image © Tom Goyon

GALLERY

In every issue we hope to inspire you with superb character designs and character-based artwork from a selection of talented professional artists. This issue features work by:

Tom Goyon | Marie Vanderbemden | Stacey Thomas

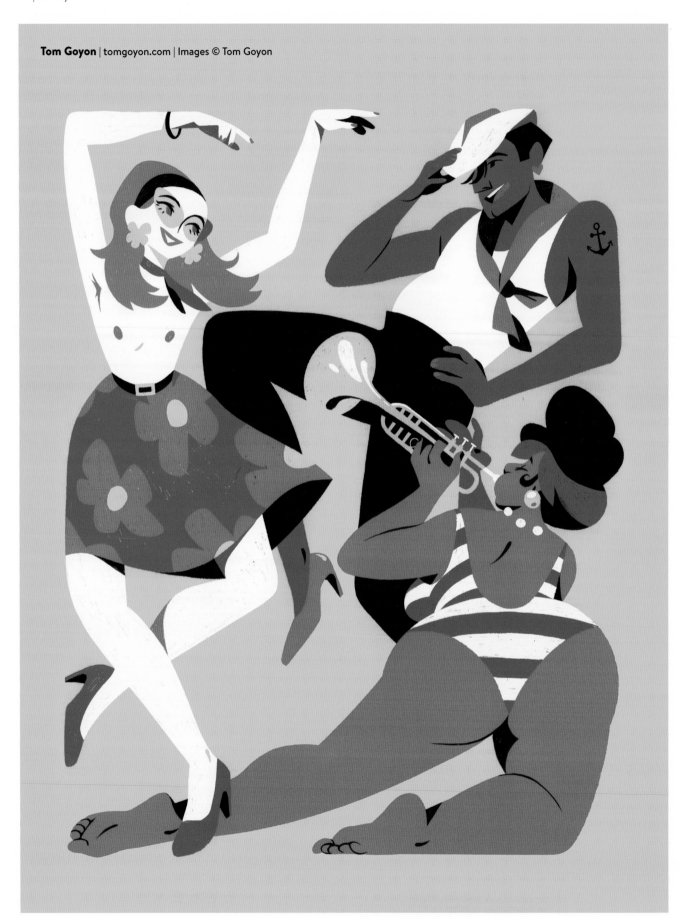

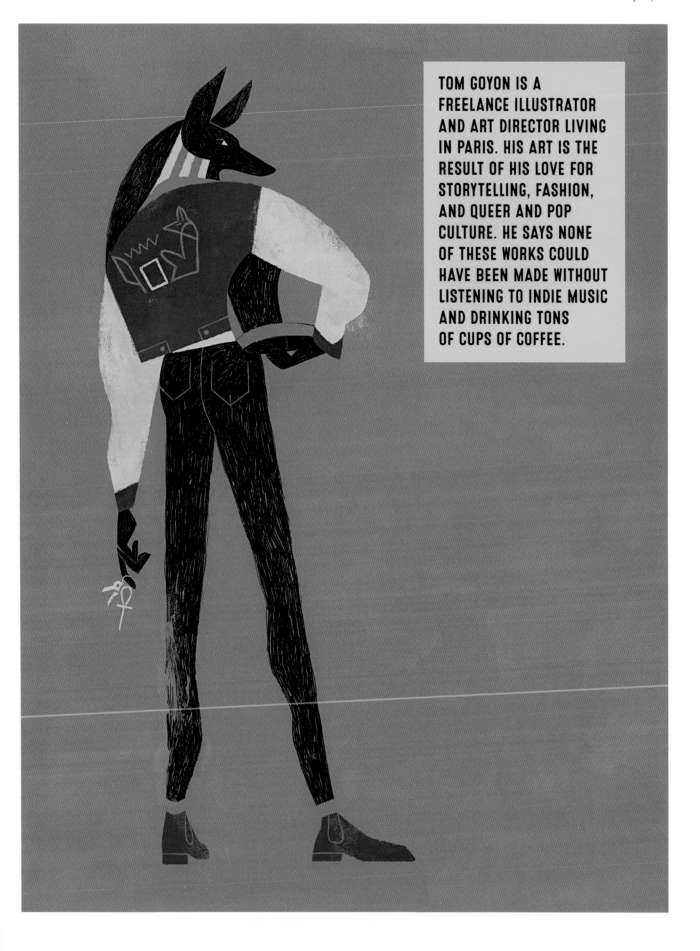

TOM GOYON IS A
FREELANCE ILLUSTRATOR
AND ART DIRECTOR LIVING
IN PARIS. HIS ART IS THE
RESULT OF HIS LOVE FOR
STORYTELLING, FASHION,
AND QUEER AND POP
CULTURE. HE SAYS NONE
OF THESE WORKS COULD
HAVE BEEN MADE WITHOUT
LISTENING TO INDIE MUSIC
AND DRINKING TONS
OF CUPS OF COFFEE.

MARIE VANDERBEMDEN IS A FREELANCE ILLUSTRATOR WHO WORKS FROM HER BARGE MOORED IN BELGIUM. SHE STUDIED ILLUSTRATION AT L'ÉCOLE SUPÉRIEURE DES ARTS SAINT-LUC IN LIÈGE, AS WELL AS 3D ANIMATION AT THE HAUTE ÉCOLE ALBERT JACQUARD IN NAMUR. SINCE 2016, MARIE HAS ILLUSTRATED SEVERAL CHILDREN'S BOOKS AND WORKS IN FILM ANIMATION.

STACEY THOMAS IS AN ILLUSTRATOR, MAKER, AND COMIC ARTIST BASED IN OXFORDSHIRE, UK. SHE STUDIED ILLUSTRATION AT THE UNIVERSITY OF BRIGHTON, GRADUATING IN 2017. SHE WORKS ACROSS DIGITAL AND TRADITIONAL MEDIA, WITH A PARTICULAR FOCUS ON INK AND GOUACHE PAINT. HER INSPIRATIONS INCLUDE FOLKLORE, ABSURDISM, AND THE NATURAL WORLD.

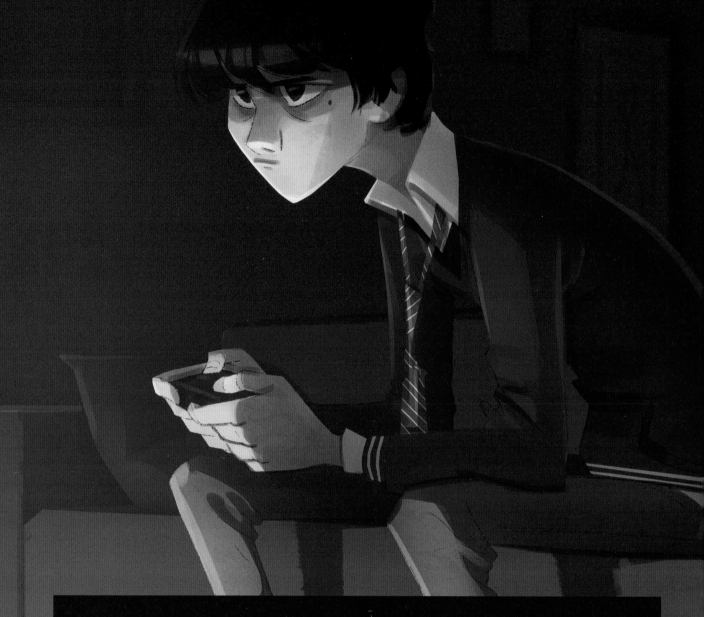

DESIGNING FROM A NARRATIVE
MEYBIS RUIZ

In this tutorial, I explain the method I use to approach the challenge of designing a character starting with a narrative text. I take you through my process, from extracting all possible information from a piece of text, to using other media to find your character. There are innumerable ways to design characters, with no one perfect way to do it. Everyone learns the theory, and little-by-little they leave behind what doesn't work for them, keep what does, learn new things, add new tools, and keep evolving their workflow. That is what happened to me – and I'm still evolving!

THE NARRATIVE

"The dawn crept through the thin curtains and lit Luke's face as the credits for the latest completed videogame scrolled down on the television. He'd done it again – missed his sleep. Still fully dressed, but wrinkled, his eyes cherry-red and half-glued, he could barely raise a smile. The controller dangled precariously from his hands. His school tie hung from his arched neck, and his foot rested on a plate of half-eaten pasta. School would be hell today, but at least the final boss had been defeated, and he had the screenshot to prove it."

INTERROGATE THE BRIEF

Having as much information as possible beforehand will help with any task. You need to understand your character's personality and motivations before beginning to sketch.

You will often be given a description that contains key information such as their appearance, ethnicity, personality, age, gender, height, weight, temperament, and when and where they live. You may even be involved at an earlier stage as part of the process of establishing this information. In this tutorial, I receive a piece of narrative, and the first thing I do is to read it as many times as necessary. First, I read it through quickly to get a feel for the narrative, then more slowly and with extra care and attention, to extract as much information as possible, and build from there.

WHAT DOES THE NARRATIVE *SAY EXPLICITLY*?

- Their name is Luke
- They are male
- They are a student
- They play videogames
- They wear a wrinkled school uniform with a tie
- Their neck is arched
- They have been up all night playing videogames
- They are tired and sleepy
- They are satisfied and proud

WHAT DOES THE NARRATIVE *IMPLY*?

- Their arched neck is due to a great amount of time sitting
- They have bad posture
- They are not very organized or neat
- They are likely a teenager with a tendency to pull all-nighters
- The game is more important than being rested for school
- They like a challenge
- They like to share their achievements with friends
- They are determined and persistent
- They like to win
- The perception of others matters

RESEARCH

Get to know the subject matter. Reality is often richer than the imagination. My first thought is "he probably wears glasses" but that is an outdated stereotype of the "nerdy kid" persona, who is in the math club and plays D&D. Today, all kinds of people play video games – check out some of the most successful pro-gamers today. So, the first step is to identify the pro-gamers and make studies and notes. Some studies of real children and teenagers will also help – I might notice features that will help ground the character.

This page (top): In this study of real-world pro-gamers, almost all have a unique feature – a piece of clothing, accessory, or hairstyle – as a way to stand out from the others. Some wear glasses, but the majority do not

This page (bottom): Observe the head shapes, hairstyles, facial features, and expressions of children and teenagers. Do they have braces? How do they move? What is their posture like?

REALITY AS INSPIRATION

When you draw from memory you tend to repeat certain features that you like. Yes, it's cozy and comfortable, but you'll start repeating yourself in your designs. I study from real life as frequently as possible, and keep a sketchbook and pencil to hand at all times. I sketch on the subway, or go out to parks or cafés and draw the people I see. I look at their posture, how they hold their bag or phone, how they stir their coffee, and how they speak and interact with others. There is an immense variety of facial features, shapes, and proportions out there. Drawing from life and references will keep you sharp, enrich your visual library, and help avoid repetition, to develop something grounded.

This page: Studies drawn from real life help to build a rich and unique reference library to use when creating a new character

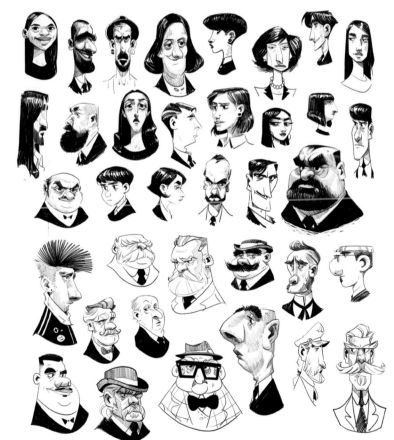

ARCHETYPES

When creating a character for a story, I imagine them in it and ask some questions:

- What is their place in the movie, comic, or whichever medium the story has been developed for?

- How does the character interact with others, such as friends, parents, or their crush?

- What is the theme of the story and how does the character fit in?

- Are they a protagonist, an antagonist, or a supporting character?

Countless theories have been developed and books written about storytelling, including psychoanalysis, which can help to pinpoint your character's identity. Joseph Campbell's books *The Hero with a Thousand Faces* and *The Power of Myth* helped me with this.

Figuring out your character's place in a story can also be helped by exploring Jungian archetypes. Jung identified twelve universal, mythic character archetypes that reside within our collective unconscious. He defined twelve primary types that represent the range of basic human motivations. Each of us tends to have one archetype that dominates our personality. I see Luke as the hero of this story. He is the protagonist; we will follow him and see his journey.

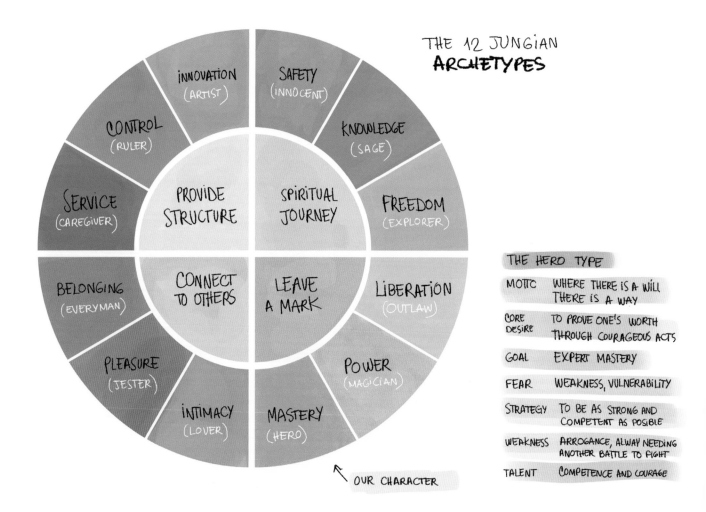

THE 12 JUNGIAN ARCHETYPES

THE HERO TYPE

MOTTO	WHERE THERE IS A WILL THERE IS A WAY
CORE DESIRE	TO PROVE ONE'S WORTH THROUGH COURAGEOUS ACTS
GOAL	EXPERT MASTERY
FEAR	WEAKNESS, VULNERABILITY
STRATEGY	TO BE AS STRONG AND COMPETENT AS POSIBLE
WEAKNESS	ARROGANCE, ALWAY NEEDING ANOTHER BATTLE TO FIGHT
TALENT	COMPETENCE AND COURAGE

OUR CHARACTER

PROPORTIONS

You have probably heard people talking about the Golden Ratio a million times already. I did too, at school, but never really understood the diagrams on top of paintings. I wish someone explained it to me as simply as world-leading character designer Stephen Silver does: "It's all about proportion." Having a large-medium-small relation between parts of a character or object is appealing to the human eye. It helps create a sense of rhythm, variation, and contrast.

I simplify my character when trying out different proportions. For this character, I don't push the proportions too far as he might appear too stylized.

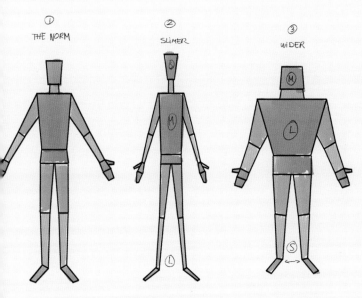

PROPORTIONS — WIDTH

Opposite page: The term "archetype" means *original pattern* in Ancient Greek. Jung used the concept of the archetype in his theory of the human psyche

This page: I like to use trapezoids as building blocks as they carry not only length and width, but also angles. These examples are marked up to show the different sized areas: S – small, M – medium, L – large.

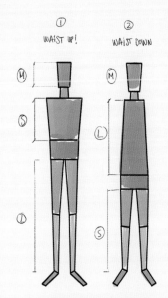

PROPORTIONS — HEIGHT

CHARACTER SHEET

At this point, after doing the initial research, I write a list detailing my Luke's defining characteristics.

- Luke, student 12–14 years old
- Skinny, arched posture
- Hair falls on his face and is a bit messy
- Determined and likes a challenge
- Does not pay too much attention to personal grooming
- Does not spend a lot of time outdoors – is a little bit pale
- Hangs out with friends at the arcade and comic-book stores
- Spends time on Reddit and Twitch
- Introverted but not shy
- Does not waste time talking or doing things he finds boring

FOCUS ON THE BASICS

There is a general principle in the design process: when drawing, always establish the biggest shapes first, then add the details. This can also be applied to the coloring and rendering stages. It ensures that the basic forms are correct before adding details. Basic forms are gesture, proportions, shapes, and structure. Do not get lost in detail – keep it simple. For example, how many folds on a sleeve are necessary? In a stylized design, every detail is a statement. Avoid unnecessary details during the design process and focus on the basics.

BODY TYPES

I go back to the narrative, where the plate of half-eaten pasta suggests that he does not pay much attention to food. If he spends his evenings playing games and goes to school during the day, he is unlikely to go to the gym, play sports, or spend much time outdoors. I decide he is neither athletic, nor overweight. He is probably very skinny so I choose more slight body types.

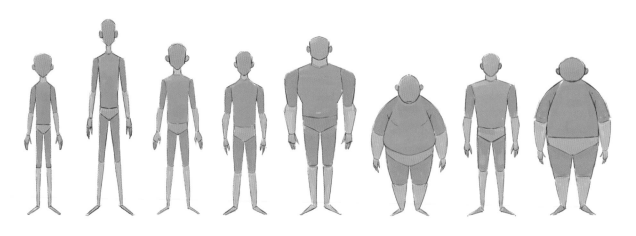

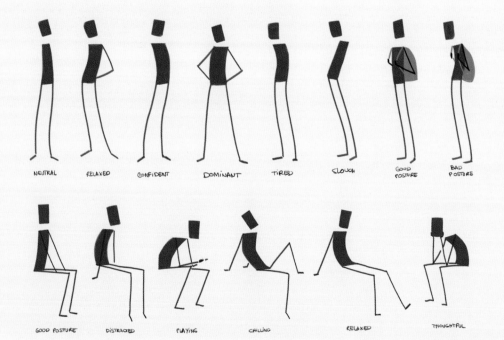

NEUTRAL RELAXED CONFIDENT DOMINANT TIRED SLOUCH GOOD POSTURE BAD POSTURE

GOOD POSTURE DISTRACTED PLAYING CHILLING RELAXED THOUGHTFUL

This page (top): Rough sketches of different body types and different proportions. Keep consistency within each design – if you use square shapes, adding a triangular head could appear inconsistent

This page (bottom): Loose and clear sketches; a stick figure should be enough to demonstrate the gesture. If it is not clear in a minimal state, it will not transfer after adding more detail

GESTURE

A character's pose and physical actions say who they are, or at least how they want to be perceived. Everyone walks or sits differently. Some people are energetic, others are more sedate. Also, how the character *feels* affects the pose; the same person walks differently if they are going to a first date or returning from a break-up. Look for gestures that best describe the character.

Think about the general feeling of the pose. If your character is calm and slow, it does not make sense to draw an open, expressive, and exaggerated gesture. The torso and legs should be enough to make the pose feel balanced. Focus on capturing the feeling first – the structure will come later. For this character, I know from the narrative that he probably has an arched back, poor posture, and is either tired or focused on playing during the day.

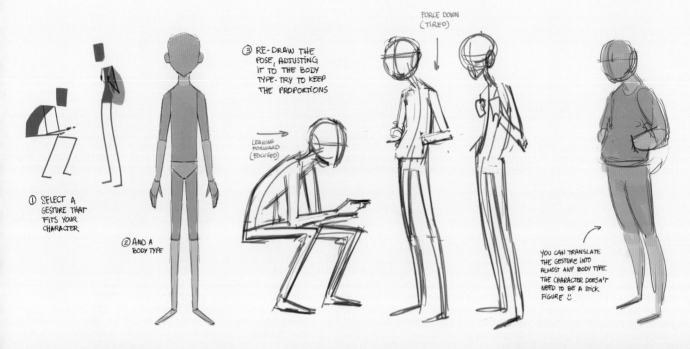

THE HEAD

We now have a body type, proportions, and gestures, so can start paying attention to other aspects, such as the head. With studies of real-life people fresh in my mind, I put the reference aside and start sketching faces from memory, trying out different shapes, proportions, placement, separation, and size of the facial features.

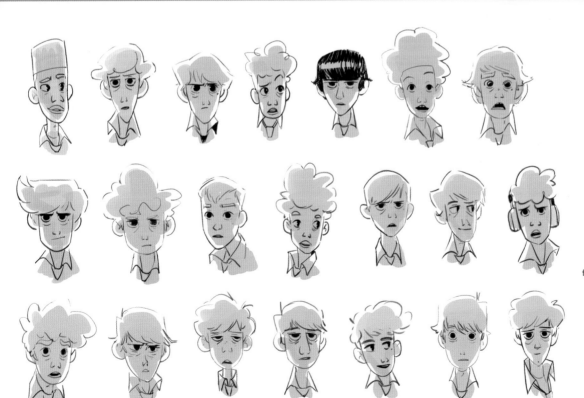

This page (top):
Gestures should work independently from the body type, up until a certain point, where the amount of weight will affect the pose

This page (bottom):
In addition to faces, try out hairstyles and maybe a unique feature, like freckles, a scar, braces, or a birthmark

SILHOUETTE

Once I have selected a body type and a gesture, I start drawing the pose, making sure it reads well. I turn it into a silhouette and check that it still translates. You should be able to get the general idea of the pose, the line of action, and the sense of weight or force of the character. Define clear shapes with balanced positive versus negative space.

CHANGING MEDIA

Exploring different techniques and changing media during the design process is very helpful. We all draw differently with a brush than we do with a pencil or pen. Crayons, for example, allow you to avoid getting into too much detail, and ink lets you think more clearly about positive and negative space. I personally go to sculpting – clay is malleable, allowing me to explore and change shapes and proportions. There is no place to hide regarding the dimensionality of the character – you have to make choices regarding volumes. When using clay (or your preferred alternative medium) focus on gesture, proportions, and shapes.

Left: My preferred alternative medium, clay sculpting, provides a great reference for my character at different angles.

CLOTHES

Clothing can be important when conveying certain aspects of your character. It can inform the viewer about their taste, sense of style, economic status, occupation, and personality. Is your character like a peacock, always grooming themselves and looking for attention? Or are they elegant and sophisticated? Is comfort their main concern regarding their attire? What the character wears and how they wear it says something about them. Luke is a student and we know from the narrative that he wears a wrinkled school uniform.

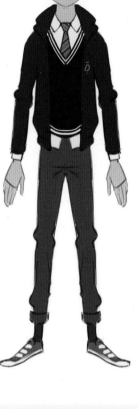

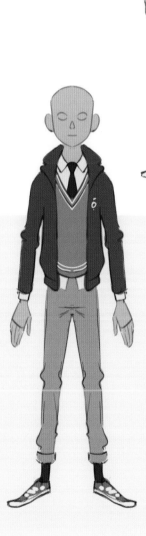

Opposite page (top):
Negative space makes the silhouette read more clearly. I was once told that "negative space is to design what silence is to music."

This page:
After studying a variety of uniforms, I put together one that feels familiar, try out different values and styles, and go with what feels most authentic – then try various color schemes

BODY LANGUAGE

As implied in the narrative, our character is an introvert and generally tired. He keeps his hands close to the body, either holding the backpack, in his pockets, or checking his phone. According to the well-known personality test Myers-Briggs Type Indicator (MBTI), introverts often prefer working alone or in small groups, focusing on one task at a time at a steady pace. These are all traits you can represent in your design through body language. Placing your character in a setting will help utilise body language in a way that is authentic to his actions. Study live-action movements on film or TV. This will help you observe nuances in how real-life people do certain things.

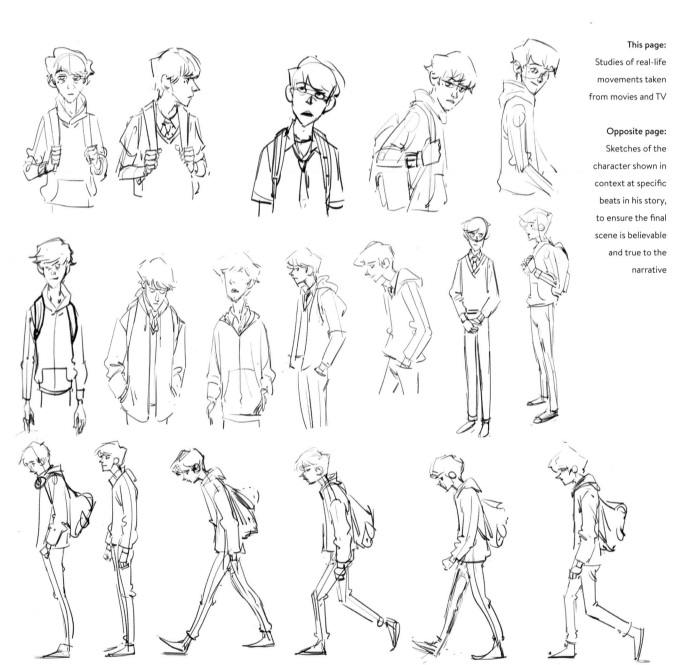

This page:
Studies of real-life movements taken from movies and TV

Opposite page:
Sketches of the character shown in context at specific beats in his story, to ensure the final scene is believable and true to the narrative

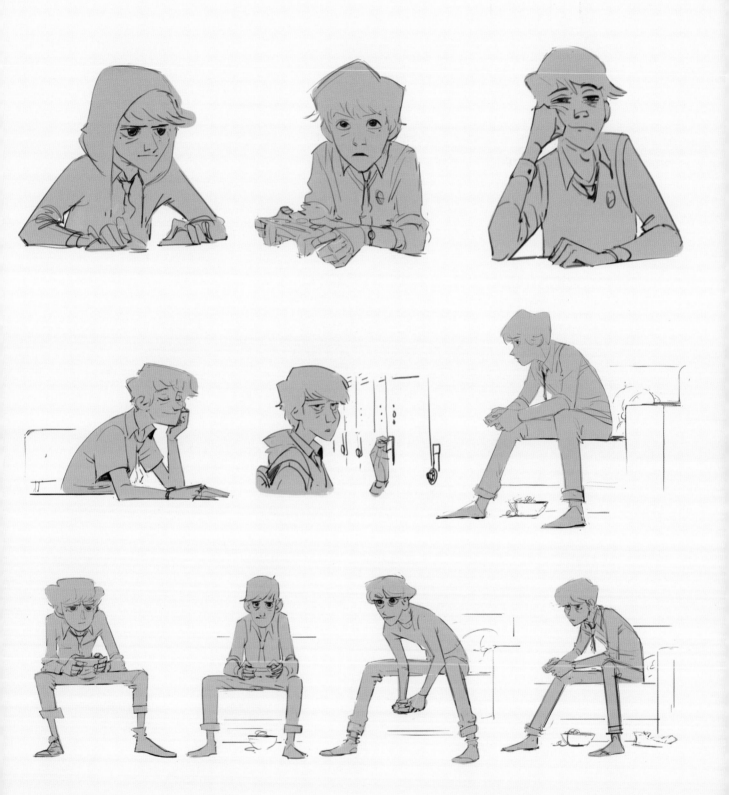

ACTING AND EXPRESSION

This is another stage where drawing from life and building a library of authentic references is most useful. When I look back on sketches I have produced from memory, often they all have the same basic expressions. Alternatively, using stills from movies and TV can help bring a variety of emotions to your character. Take screenshots and make your character "act" the emotions shown – you will be amazed by the results!

This page (top):
A range of sketches showing expressions gleaned from movie and TV screenshots

This page (bottom):
Process from gesture to final pose

Opposite page:
Final image ©
Meybis Ruiz

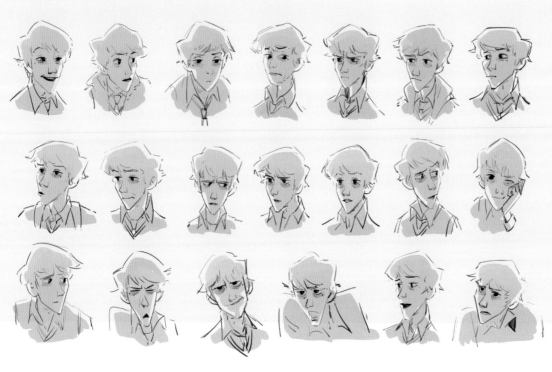

CLEAN UP

Once I decide on the character's gesture, I start to construct the final pose, add some structure to it, and perfect the volumes. Then I add all the other details like clothing, facial expressions, and hairstyles. I finish by adding color if necessary, and lighting. In this case I want to add lighting to portray the intensity of the moment, where he is just seconds away from victory.

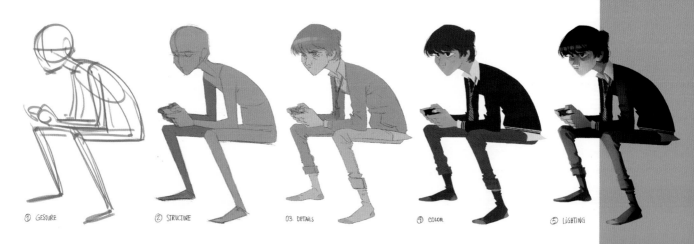

① GESTURE ② STRUCTURE 03. DETAILS ④ COLOR ⑤ LIGHTING

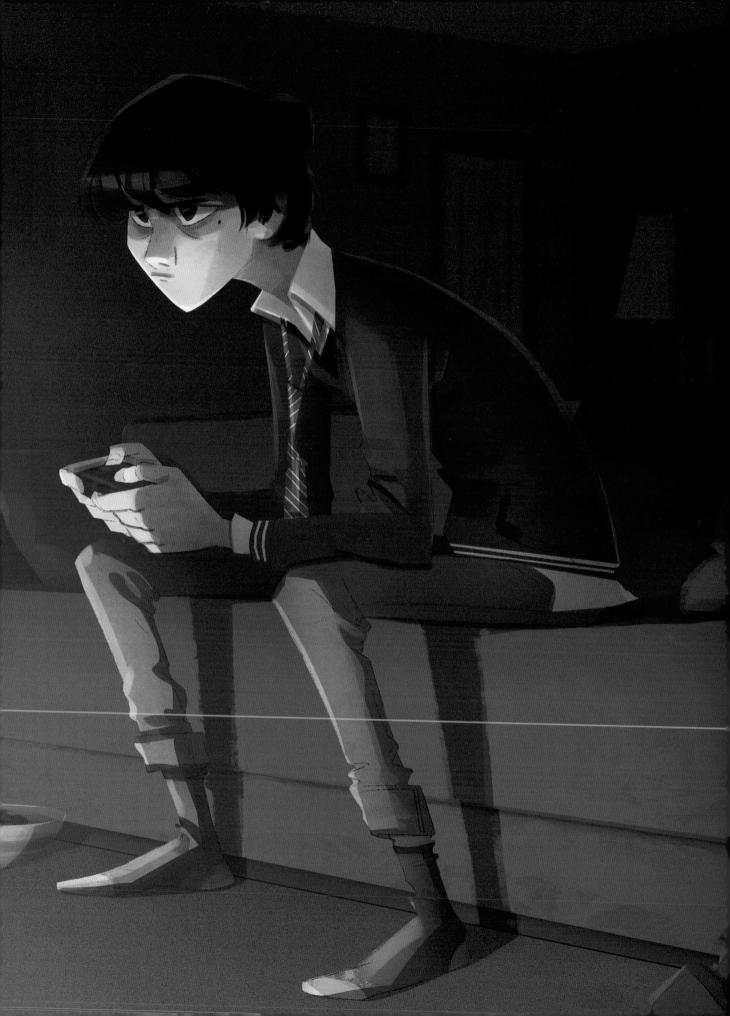

CONTRIBUTORS

IZZY BURTON

Illustrator, artist and
animation director
instagram.com/izzyburtonart

Izzy works as a freelance director
with both Passion Pictures and
Troublemakers, and is an illustrator
represented by the Bright Agency.

LOBÓN LEAL

Cartoonist and
character designer
instagram.com/lobonleal

Cartoonist and character designer
Lobón studied Fine Art in Madrid,
and now teaches digital illustration
and character design.

FAUSTINE MERLE

Student at Gobelins
L'ecole de L'image
instragram.com/faust_merle

Faustine is currently a student at
an animation school in Paris. She is
passionate about character design
and visual development.

TOSHIKI NAKAMURA

Freelance character designer
and visual development artist
artoftoshi.com

Toshiki is a freelance character
designer based in Japan. He is also
a children's book illustrator and is
passionate about storytelling.

ELÉONORE PELLUAU

Character designer
instagram.com/eleonore_art

Eléonore is a French artist who
loves nature and cuteness, and
those are the main themes of her
inspiring illustrations.

TIM PROBERT

Art Director at Nathan Love
and freelance illustrator
timprobert.com

Tim balances his work at animation
studio Nathan Love with personal
projects. He is currently working on
his own graphic novel, *Lightfall*.

RED KNUCKLES

An independent animation studio
run by Mario Ucci and Rick Thiele
redknuckles.co.uk

A London-based studio founded by
artists. They work across multiple
disciplines and media on content for
advertising, music, TV, and more.

JUSTIN RODRIGUES

Lead character designer for
Disney Television animation
instagram.com/jtown67

Justin has worked in the animation
and entertainment industry for
almost 10 years, including with
Disney, Netflix, and DreamWorks.

MEYBIS RUIZ

Illustrator and
graphic designer
meybisruiz.com

Meybis has a great love for
typography and visual arts, and
loves exploring new techniques and
workflows – currently sculpting.

JENNIFER YANG

Character designer
and story artist
instagram.com/stripedpants

Jennifer studied 3D computer
animation before moving to LA to
work freelance, drawing characters
and illustration for animation.

HEAD ANGLES

BY LORENZO ETHERINGTON

THE MORE YOU *PUSH YOURSELF* TO DRAW YOUR CHARACTERS FROM *DIFFERENT ANGLES,* THE BETTER YOU UNDERSTAND AND CAN VISUALISE THEIR HEADS IN *THREE DIMENSIONS,* AS WELL AS THE *SPACING* AND *UNIQUE CHARACTERISTICS* OF YOUR DESIGN.

HERE ARE *SIX MORE COMMON HEAD ANGLES* – IN EACH CASE WE'RE SHOWING *FORM* THROUGH FEATURE *POSITIONING!*

FACE-ON TILT FORWARD

AT THIS ANGLE, BROW LINE CURVES:

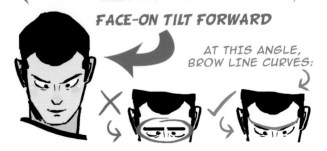

FACE-ON LOOK DOWN

BOTTOM OF EARS LINE UP WITH EYES

NOSE TIP LINES UP WITH MOUTH

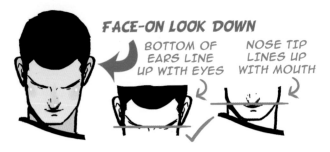

3/4 — FAR EYE IS NARROWER IN WIDTH, BUT THE SAME HEIGHT:

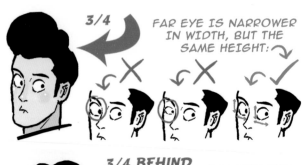

3/4 BEHIND

GAP BETWEEN HAIRLINE AND BACK OF EAR:

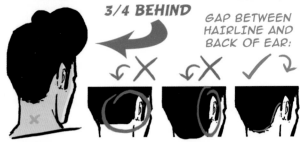

3/4 TILT FORWARD

ON A CHARACTER *OF THIS BUILD,* CHEEK LINE CROSSES TIP OF NOSE:

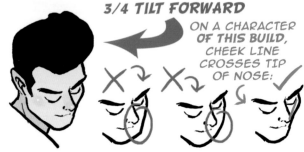

3/4 BELOW

FACE *IS* A CURVED SURFACE, BUT EYES STILL ALIGN IN A STRAIGHT LINE HERE:

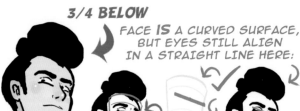